ABOUT ROTHKO

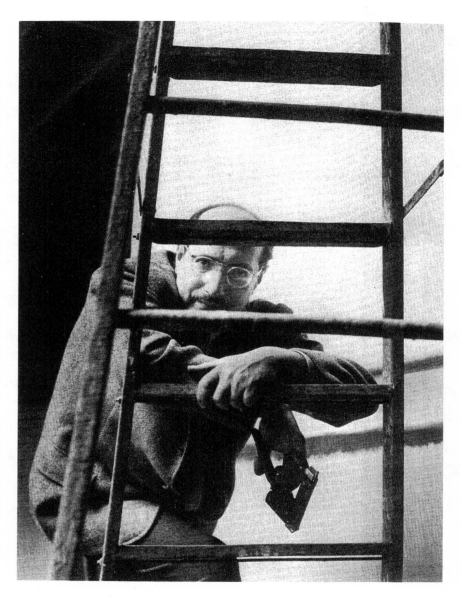

Frontispiece Mark Rothko in his studio, 1952

ABOUT ROTHKO

DORE ASHTON

DA CAPO PRESS

A Member of the Perseus Books Group

Cataloging-in-Publication data for this book is available
from the Library of Congress.

First Da Capo Press edition 1996
Second Da Capo Press edition 2003
ISBN-10: 0-306-81264-9 ISBN-13: 978-0-306-81264-4

This Da Capo Press paperback edition of *About Rothko* is an
unabridged republication of the edition first published in New York in
1983. It is reprinted by arrangement with Oxford University Press, Inc.
and Artists Rights Society.

Paintings by Mark Rothko ©1996 Kate Rothko-Prizel &
Christopher Rothko / Artists Rights Society (ARS), New York

Cover painting from Bettmann Archives by way of Artists Rights Society.

Published by Da Capo Press
A Member of the Perseus Books Group
http://www.dacapopress.com

Da Capo Press books are available at special discounts for bulk
purchases in the U.S. by corporations, institutions, and other
organizations. For more information, please contact the Special
Markets Department at the Perseus Books Group, 11 Cambridge
Center, Cambridge, MA 02142, or call (800) 255–1514 or
(617) 252–5298, or e-mail j.mccrary@perseusbooks.com.

PREFACE

I call this book *About Rothko* because in both senses—all around and approximately—writing of painting is always "about." Even more, writing of an artist is always approximate. No amount of factual or biographical detail can ever comprise an adequate portrait. All biographers know how maddeningly diverse responses to an artist's personality can be. I have had countless experiences with Rothko's friends and acquaintances that bear out my own perception that Rothko's complex personality yields only rarely to generalizations. His nature revealed itself reluctantly, even to friends, and they often had totally opposite reactions. To a large degree I have finally relied on my own friendship with Rothko that lasted from my youth to his death in 1970—some eighteen years.

Most of my conversations with Rothko occurred during studio visits or over lunch. In the early years it was mostly pastrami sandwiches in 6th Avenue delicatessens. Toward the end, we lunched in elegant uptown Chinese restaurants. But the conversations were much the same. We fell into a kind of philosophical badinage. We talked about "life" the way we imagined the old Russian literati used to talk—long, meandering conversations that often concluded with a sigh, and an agreement that it is hard to find a way to live an ethical life. Most of our allusions to art were within that larger context.

When I first knew him, I caught glimpses of the wit and gusto for

which Rothko was known in his earlier years. There was often tenderness in his greeting, sometimes even exuberance. Many friends recall the great warmth of his salutational smile, his eyes soft behind his thick-lensed glasses. Sometimes after the first moments a certain distractedness descended. Rothko was a nervous and often impatient man. Sometimes at dinner in my home, he would get up and wander between courses, cigarette in hand. But there were also times when he was intensely interested in a certain subject and would speak with great animation and listen intently. When his mind was distracted, his shambling gait and a certain vagueness in his glance would indicate his unwillingness to linger in conversation.

There was certainly anger in Rothko. Most of his close friends accepted it and understood that some of it was bred in the loneliness of the studio routine, and some evoked by his general condition of doubt. Like K. in *The Castle*, Rothko spoke the same language as the others, but for some permanently obscured reasons, the others didn't often understand. Perhaps his *pudeur*, which prevented him from exhibiting what was certainly a romantic and sometimes sentimental soul, contributed to his isolation. He spent a lot of emotional energy preserving himself from intrusion and fending off overheated responses to his life's work. Although his paintings progressed from metamorphosis to transfiguration, he adamantly denied in public that they represented for him (and now for many others) a kind of *ekstasis* (*ex:* out of; *histanai:* to set, to stand). Yet, he was most affectionate with those who sensed the depth of his passion, and who knew that his protestations were somehow ritualistic.

Rothko committed suicide February 25, 1970. He left an estate in such disarray that one of the most complicated lawsuits ever to take place after the death of an artist sensationalized his name. Since I am writing about what Rothko called "the meaning of a man's life's work," there is no place in my book for the notorious trial.

New York D. A.
December 1982

ACKNOWLEDGMENTS

I thank Bonnie Clearwater of The Rothko Foundation, and the Archives of American Art for their generous and patient assistance. Many friends and acquaintances have shared their experiences with me, and they all have my warmest gratitude: Andrew Forge, George Dennison, Ronald Christ, Matti Megged, Ned O'Gorman, Robert Motherwell, Richard Roud, Carla Panicali, Carlo Battaglia, Toti Scialoja, Gabriella Drudi, Elaine de Kooning, Sir Norman Reid, Peter Selz, Herbert Ferber, Donald Blinken, Joseph Liss and Mrs. H. R. Hays. A special thanks to Tony Outhwaite, whose enthusiasm spurred my work; to Geoffrey Hoffeld of the Pace Gallery, and above all to Kate Rothko Prizel for her graciousness.

D. A.

ABOUT ROTHKO

Ah, whom then can we prevail upon in our need? Not angels, not men,
and the clever animals see at once
that we are not very securely at home
in the interpreted world.

RILKE, "First Duino Elegy,"
Translated by Edward Snow

1

Rothko did not feel "very securely at home in the interpreted world." He looked about him. He searched faces. He traveled. He married and had children. But he was never at ease. He was indifferent to objects, and took little pleasure in the ordinary embellishments of daily life. In his various studios austerity reigned. There were no distractions—no bibelots, reproductions, Oriental rugs or even comfortable chairs. His sensuous and emotional life were not dependent on paraphernalia or possessions, even small ones. He craved transport, and found it mostly in music. His greatest fund of emotion was lavished primarily on what he made—paintings. Those paintings were to be his passport to a more luminous world, not encumbered by our nouns and adjectives, our interpretations that always fall short. They were prepared by careful thought, nurtured by well-fondled ideas, but, as he said, "Ideas and plans that existed in the mind at the start were simply the doorway through which one left the world in which they occur."[1] To leave the world in which ideas and plans—so quickly superseded by emotions—occur was essential to Rothko. The doorway was as eagerly sought as Kafka's portal. His was a temperament that had unquenchable thirst and hunger. He had deep needs to fulfill, many of them incapable of being brought to the threshold of language.

Like many artists of the modern epoch, Rothko could not make use of either angels or men. The angelic order, he sensed, was no

longer available. He was a Nietzsche admirer. But the world of men, interpreted, as it was, always by its surfaces, could not be enough. Although he made a *salto mortale* in his paintings, and was immensely admired as well as reviled for his departure to the pure realm, he resolutely resisted attempts to thrust him into categories that bordered on mysticism. He hovered, in his mind, on the threshold of the doorway, but was wary, like most moderns, of an irreversible journey. He insisted he was a materialist: "When I wrote the introduction to Clyfford Still's catalogue for Peggy Guggenheim, I spoke of earth worms (primordial matter)—that's far from *otherworldliness!*"[2]

And yet, there were the works—his own environment wrought over a long period that, to so many, spoke of another place. There were countless responses to the gesture of renunciation that brought Rothko into a realm in which his needs could be fulfilled, at least partially. The large abstract paintings that moved so many, and continue to move those attuned to such experiences, could not be perceived as the work of a "materialist," and there were times when Rothko himself alluded to their "transcendence." Somewhere in him was the lover of the absolute. Some viewers responded immediately to the experience; others were skeptical. Those who were not emotionally available, or who saw sameness in Rothko's later work, with its simple and repetitive compositional schemes, were irritated by and, at times, contemptuous of the extravagant claims made by those who were, often unaccountably, moved. The derogators harped upon the sameness. Brian O'Doherty insisted that "Rothko's art utters a single word, insistently." Rothko's defenders found little to say that could convert the unbelievers. It was quite true, as O'Doherty and others complained, that the literature on Rothko's work tended toward the exalted, and was always "subjective." The analysis of individual paintings, on which detractors could build their case, seemed a secondary concern to those who were moved and wished to bear witness to the power of Rothko's oeuvre on an unnameable spiritual or emotional level. They—the ones who spoke of sinking into his spaces; of feeling lighter, or of feeling awe; of having a spiritual experience—had understood that Rothko's "enterprise," as he referred to his life's work, was to find some philosophical resting

place. Like many poets and philosophers, he needed to feel (not only think) some kind of underlying unity in the havoc of existence. Willem de Kooning understood very well. He congratulated Rothko on his exhibition at the Museum of Modern Art in 1961, saying "Your house has many mansions." He explained: "You see, because knowing the way he made them, all those paintings became like one with many mansions."

Certainly it was often a house divided. Rothko was an intellectually restless man. He was by nature a debater, first of all with himself. Those who noticed his contradictions, both in his few public statements, and in his concourse with others, sometimes remarked that Rothko could be like a lawyer, or like a devil's advocate. Yet he seemed to long for the release that would reveal a wholeness beneath what seemed to him, and so many other modern creators, a devastatingly chaotic existence.

If he talked again and again of his "enterprise" it was to emphasize to himself the potential meaning of its wholeness. On occasion he would call it an "ellipse." Enterprise: "An undertaking, esp. one which involves courage, energy or the like; an important or daring project; a venture" (Webster). Rothko's "project" went beyond painting, although painting, finally, was his only means.

A friend of Rothko's youth, the painter Joseph Solman, marvelled at what he called Rothko's "growth." Rothko was after all forty-six years old in 1949, the year that he made his most daring painting gesture. All the years before he had struggled to make painting the instrument of his inner life, often with discouraging results. Yet something had prepared him for his mature decisions. His insecurity in the interpreted world was probably the deepest force, driving him past its barriers throughout his life. Such uneasiness is a familiar condition of certain artists. Rothko's older brother stressed that he had been a highstrung, noticeably sensitive child. In addition to an inborn uneasiness, however, there were circumstances in his early childhood that worked against an easy adaptation to vicissitudes.

In a life with many turnings, there are fragments of memory that return and retreat. Certain fixed images that have somehow withstood the avalanche of events that overtake a man, seem to have a

bearing on his evolution. Rothko carried in him childhood impressions that were ineradicable. He remembered his early family life without enthusiasm, and it would be hard to tell how it affected his life. But the external events that affected his family were deeply graven. When Rothko reminisced about his early childhood he most often recalled the situation, *his* situation, as a Jew among hostile Russians. He did it obliquely: he told of being a child of five and watching, in terror, as Cossacks brandishing their *nagaikas* bore down on him. Those eager to disparage Rothko's self-dramatization are quick to point out that he was born in Dvinsk, one of the most comfortable cities for Jews at the turn of the century. On the whole, the large Jewish population of Dvinsk was spared the atrocious pogroms that took place in other towns in the Jewish Pale, although they shared in the frequent indignities all Jews in Czarist Russia endured. Dvinsk before the First World War had a population of roughly 90,000, nearly half of whom were Jews. It was a busy railroad junction; an important military fortress, and an unusually developed industrial town. Labor unrest was constant after the turn of the century. Many of the burgeoning radical political movements were well represented in Dvinsk, including the newly formed Zionist socialist groups. After the failure of the 1905 revolution, Dvinsk was carefully watched by the Czar's secret police. When the Cossacks came, often to break strikes mercilessly, the Jews were their first target. During the year of Rothko's birth, 1903, there had been the terrible three-day pogrom in Kishinev, followed by others in Russian towns with increasing frequency. Jewish communities after 1903 lived in constant fear, as slogans such as "Destroy the Jews and Save Russia!" were increasingly sanctioned by the Czar. Old friends have remained skeptical that Rothko ever encountered the rampaging Cossacks. Yet, of all the possible memories he could preserve of his first ten years, that is the memory that he most often cited. It could stand for everything else. Certainly the position of the Rothkowitz family in 1903 was precarious. Every Jew knew the dangers. Although Rothko's father, Jacob, was a professional and made a comfortable living as a pharmacist, life for the Jews was never without fear. When Rothko was two years old the first revolution broke upon Russia, driving the Czar to further extremes. In

6

Dvinsk, where there was an educated Jewish populace and where progressive political views were common, the anxiety mounted and surely conveyed itself to the youngest child.

Although Rothko came from a family of emancipated Jews (his parents were ardent Zionists and spoke Hebrew as well as Russian),[3] his father decided that his youngest son would have a formal religious education. The child was sent, probably at the age of five, to a Cheder, a religious school, where in all probability he began the process of memorizing the Talmud and learning the Hebrew scriptures under the strict eyes of teachers who had little thought for the individual differences among their students. Even if Rothko attended one of the more enlightened religious schools, where instruction was sometimes conducted in Yiddish, and where there were the beginnings of a liberal education, the strictness of the regime, the demands on young scholars, and the emphasis on the authority of the teacher could have certainly contributed to Rothko's later hatred of invested authority. At home there were three siblings, all much older: Sonya, fourteen, Moise, eleven, and Albert eight years, when Rothko was born. There was not much latitude for play. Rothko often remarked that he had never had a chance to be a child.

When Rothko was seven years old, his father decided to make the break that so many Russian Jews had made during the twenty years of turmoil. He left for America where a brother had already established himself, planning to bring his family as soon as he could. Within a year he was able to arrange for the escape of Albert and Moise, who were nearing the age of conscription—a disaster that all Jews dreaded. Young Marcus was left with his mother and older sister in a community in general upheaval. Among their middle-class acquaintances there were undoubtedly young radicals who were quick to predict the coming social revolution and whose efforts were frequently terminated by the increasingly violent methods of the Czar's secret police. An intelligent boy nearing the age of ten would not have failed to respond to the extremely volatile situation. The knout of the Cossack was the symbol that summed up Rothko's memories of his Russian childhood.

When, in 1913, Jacob finally sent for the rest of his family, they

were able to travel second class, escaping the agony of so many Russian Jews whose experiences in steerage are legendary. They arrived knowing no English and undertook their long train journey to Portland, Oregon, where the father had found employment in his brother's clothing business. Rothko's memories of his life in Portland were tinged with the bitterness of the poor relative. His father had died within months of their arrival, and Rothko's mother, sister, and older brothers were faced with the immediate problems of survival. They were helped, but apparently grudgingly, by the already established family who employed the older boys in menial positions, and put young Marcus to work in the stockroom at a very early age. A life of selling newspapers and working regularly after school did not undermine Rothko. It seemed to enhance his underlying seriousness. He quickly mastered English and while still in grade school became deeply interested in the social problems discussed just as avidly as they had been in Russia. Portland's Jews lived, as they had in their mother country, largely in one neighborhood, and maintained their ties through sharing a common language, Yiddish or Russian, and congregating in community centers. Families such as the Rothkowitzes had already been broadly exposed to theories of social liberation in Russia. In America, they experienced exhilarating relief from the perils of an authoritarian regime, and they were quick to respond to native radical movements. At an early age Rothko found an outlet for his passionate temperament in the excited discussions of social radicalism that took place in the Jewish community center. He even developed a reputation as a skilled debater, according to his brother. He always remembered his attraction to radicalism with an affection for the child he had been— eagerly attending the mass meetings at which such colorful anarchists as Emma Goldman, William Haywood, and assorted figures in the Industrial Workers of the World harangued on various issues, from the right to strike to birth control. Portland was an important stop on the West Coast circuit. Long before the Rothkowitzes arrived it had harbored a small community of intellectuals eager to preserve constitutional rights. The extravagant child of the anarchist movement, Emma Goldman, had early established her name there as one whose rights to free speech must be protected. In her

8

memoirs she warmly recalls certain distinguished citizens of Portland, among them an ex-senator, a Unitarian minister, and an editor of the *Oregonian,* all of whom insisted on her right of free speech. The I.W.W. held frequent meetings in Portland, bringing the workers messages from the East and Midwest where a number of strikes had resulted in almost military skirmishes. The workers were most often the casualties. Pinkerton men, hired by the big capitalists, were never loath to finish off the militants, and where they failed, the U.S. courts often succeeded. The undertone of violence in American life and the outrages obviously bestirred the young immigrants who were all too familiar with social injustice. While no child could avoid wishing to leave his foreignness behind, many of the Russian Jewish youths clung to their social revolutionary theories, carried with them from childhood. Rothko was no exception. Often in later years, he would stress his Russianness. He wished to be perceived as Russian.

Rothko was fourteen when the Russian Revolution occurred, bringing great excitement to the young American radicals and deeply marking American life. Not only did the revolution fire American social idealists with new zeal, but it frightened the government, as it did other governments. After any large-scale social upheaval, most governments, as Emma Goldman was quick to point out, resort to repression. The Americans were no exception. For the youths of Rothko's generation, it seemed essential to fight reaction and to stand for the working man's rights. Rothko threw himself into the spirit and dreamed of being a labor leader. Certainly when he graduated from Lincoln High School in only three years with what the *Oregonian* described as a brilliant record, his artistic yearnings had not yet focused. He had already taken some art classes, and shown a serious interest in music (he taught himself to play the mandolin), but the expectations of the immigrant Jewish community did not lie in the arts. When he and two other Portland Russian-Jewish immigrants were granted scholarships by Yale University, Rothko went with the intention of finding a respectable profession—the kind that his background and formation would honor.

If Princeton in the 1920s was as snobbish as F. Scott Fitzgerald reported, Yale was even more so. It was an unlikely place for three

young radicals. Rothko could not have been comfortable within the ivy-clad halls where it was well known that there was a Jewish quota, and where no Jew had ever been appointed to the permanent faculty. He apparently spent a lot of time off campus with his New Haven relatives, some of whom remember intense discussions with him about the arts, particularly music. He followed the usual courses in liberal arts and sciences; was good at mathematics, and in his second year when his scholarship was terminated, had to work as a waiter and delivery boy to make ends meet. His interest in social issues did not abate, and was reflected in the fact that he and two others published, briefly, a critical newsletter the response to which may have contributed to his total disaffection with Yale and his decision to quit after his sophomore year. One of his fellow students remembers that he hardly seemed to study, but that he was a voracious reader. If he did, indeed, see himself in the Russian tradition of youthful radicalism he would have found the classroom tedious, and prided himself on his education through his own reading. He clearly admired the anarchists who, at their best, were readers in several languages. Emma Goldman fairly often gave lectures on the Russian writers and also on the German philosopher Nietzsche. With his thoughts on "one big union" as Haywood used to call the I.W.W. goal, Rothko would not have been an ideal Yale student. Moreover, he entered Yale in 1921 when America, still under the shock of the Russian revolution, was responding apprehensively. There had been the Palmer raids in 1919 in which many young immigrants coming from the same background as Rothko had been rounded up, humiliated, and sometimes deported. A permanent Red scare was initiated by Mitchell Palmer which spilled over into renewed assaults on organizers of labor. If dreams of music and the arts accompanied Rothko as he made his way through two years of Yale, probably other dreams—of social equality, for instance—were just as insistent. The ideal of the self-educated anarchist seemed to lie behind his decision to take off for New York, as he said, "to bum about and starve a bit."

In New York he took a room with a Mrs. Goreff at 19 West 102nd Street, and began his adult life. Surviving at odd jobs in the garment district, including that of a cutter, and, as was often the custom,

taking a little help in the form of a bookkeeping job with a relative, Rothko at twenty seemed resourceful. No doubt the gospel of the anarchists fired his ambition to experience the life of a worker, but it wasn't long before he found his way to the Art Students' League. By January 1924, he was enrolled in George Bridgman's anatomy course, and probably took a sketch class as well. Still undecided, the twenty-one-year-old Rothko returned to Portland for a time where, as he often proudly recounted, he joined a theater company run by Josephine Dillon, wife of Clark Gable. The theater experience seemed important to Rothko although he apparently made no attempt to stay in the theater but returned to New York a few months later and was soon enrolled again at the Art Students' League.

This time, however, Rothko enrolled in the class of Max Weber, taking both Weber's still-life class and another in life sketching. Weber was then forty-four years old, a Russian-born Jew who had, like Rothko, come to America at the age of ten. He was considered a star at the League, where students flocked to his classes and respected him for being a "modern" artist. In fact he was a living repository of modern art history. He had ventured to Europe while still a student to seek out the work of El Greco, then considered a rare precursor of modern art. He had studied the masters of the early Renaissance in Italy, and in 1905 had settled in Paris just in time to see the scandalous salon in which Matisse, Vlaminck, and Derain struck their blow against Impressionism and called upon themselves the wrath of the critics, who dubbed them wild beasts. The twenty-four-year-old Weber was only too ready to accept the rebellious French avant-garde and enthusiastically responded to its interest in the art of primitives (even French so-called primitives— he became a friend of Rousseau). Above all, he shared their interest in Cézanne who had finally, after his death, come to be regarded as a genius and father of the modern spirit. Matisse also exercised influence on Weber, who was one of the first pupils in Matisse's short-lived school. "In 1908, when Weber returned to America," wrote James Thrall Soby, "he brought with him four dominant impressions of his years of study in Europe. He remembered above all the sinuous Mannerism of El Greco, the solid masonry of Cézanne, the bold, sweeping arabesques of the *fauves*, the searing distortions of tribal

11

sculpture."[4] To this Weber added the newly arrived Cubist approach within a very short time, thus covering every aspect of the foundations for 20th-century art. By the time Rothko encountered him, Weber was already celebrated for his early works in a primitivistic manner, where echoes of tribal art were frequent, and for his adaptation of the Cubist spatial canon to an essentially Expressionist vision. He had left Cubism behind, however, and during the 1920s Weber concentrated on expressionist figure studies in landscape settings and still-lifes. As a figure painter, he emphasized the expressive gesture of the nude. Although the inspiration is definitely Cézanne, particularly in his rendition of mountains, the atmosphere of Weber's grouped nudes is tempered by a consciously expressionist goal. The nude was to be the vehicle of the artist's emotion. And its environment was to be an evocation of mood.

In teaching, Weber stressed the importance of the figure in the history of art, and above all, the importance of interpretation. He was however still a "modern" artist and shrank from the classical reaction that had overtaken both Europe and America after the First World War. The great "call to order," encouraging a return to naïve realism and to mimesis or "objectivity" as the basis of painting was antithetic to Weber's early modern idealism. Weber had, after all, been one of Stieglitz's band of intrepid modernists. He had fought the philistines side by side with Marin, Dove, and Hartley. Later, he had tried to infuse the Cubist idiom with expressive subject matter, often drawn from Jewish themes. A man small in stature, he had enormous ambitions, and strong opinions. The young Rothko was clearly in his thrall.

Rothko's earliest sketches show him striving to find expressive distortions of the figure, clumsily and hesitantly, with Weber's own work in mind. Weber's allusions to the short, stumpy female figures of certain African tribes, from which Picasso had drawn; and his memory of Cézanne's bathers, were assimilated by Rothko who was clearly straining to learn a language adequate to his as yet unrefined strong feelings. Interspersed with the studies of conventional nude poses in Rothko's earliest sketchbooks are a few drawings of mothers and children, showing the young Rothko tentatively expressing a tenderness in terms of subject. His still-life essays also showed con-

1. Untitled no date, probably early 1930s

2. Untitled no date, probably early 1930s

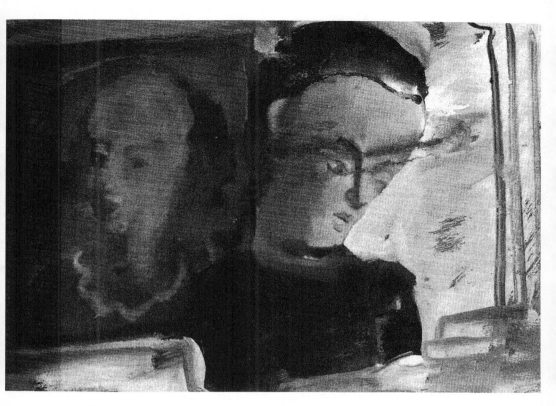

3. Untitled c.1925-27

siderable awkwardness, even for a beginning art student. But it was clear that during the two years he spent sporadically studying with Weber, he had absorbed many principles from which he could move on in experiment. Weber's views were available in a small book published in 1916.[5] To judge by the work of his students and their reminiscences of his classroom talks, his basic ideas had not changed by the time Rothko attended his classes. He said such things as:

> Always it is expression before means. The intensity of the creative urge impels, chooses and invents the means. . . . But the wonder and blessing of the spirit is that it can manifest itself best through the simplest means and that it knows no technique. . . .

> The imagination or conception of an arrangement of forms or of a particular gamut of color in a given rectangle is not a matter of means, but an inner spiritual vision. . . .

> Expression is born in stillness and in solitude. It is as if one were listening to time and telling what he hears.

In his experiences at the League, Rothko for the first time had a taste of the nature of artistic life in New York. He made a close friend among his fellow students, Louis Harris, and probably at Weber's instigation, began to make the rounds of the galleries. The expressionist mood at the Art Students' League was informed by a few exhibitions from Europe presenting the work of Rouault as well as the German Expressionists. In 1923 J. B. Neumann had opened his "New Art Circle" on Fifty-seventh Street with his motto emblazoned over the door: "To Love Art Truly Means To Improve Life." Neumann had been a successful young dealer in Germany and now was preparing to introduce to America such rising stars as Paul Klee, Ernst Kirchner, and Max Beckmann. In addition, he was eager to find American artists and soon became Weber's dealer. Neumann really believed that art could improve life and worked tirelessly to persuade the often recalcitrant American public. He was a man of vast interests and boundless enthusiasm who, in his intermittent publication *The Art Lover*, "devoted to the neglected, the misprized, and the little known," published reproductions of such various works as African sculpture, ancient sculpture, northern Eu-

4. Untitled c.1929

ropean Renaissance woodcuts, American Indian and colonial American works along with the latest works of Klee, Max Beckmann, and Weber, or an occasional El Greco. He was always cordial to students, often taking them into the back room to see his latest acquisitions, talking to them of his encounters with great minds, and referring them to books in which indispensable information or inspiration resided. He was an enthusiast.

After Rothko ceased to attend the Art Students' League regularly, he worked doggedly to improve his drawing, and to find adequate means to express his temperament. His sketchbooks show him trying to compose and invent as well as to record. He worked with the same motifs as many of his contemporaries ranging from landscape to still-life, from interiors to genre scenes. Evidence that he was familiar with Weber's small gouaches appears in the late 1920s: generalized figures in expressive postures rendered in a hazily romantic atmosphere. These early works were never literal. Even cows and horses were portrayed as taking part in some special mood and deliberately painted in a quasi-primitive mode. Rothko also tried his hand at depicting the urban environment, such as the Elevated, or scenes of life in the crowded quarters of the poor where most of the young artists lived.

His connection with the ASL was apparently maintained. In 1928 Bernard Karfiol, an instructor at the League, assembled a group show for the Opportunity Gallery in which he included both Rothko and his fellow student, Lou Harris, as well as Milton Avery, a forty-three-year-old painter who had come to New York three years before. Rothko had met the first requirement of the professional—exhibition—at the age of twenty-five.

2

Rothko always maintained that he was self-taught, and that he had learned in the beginning from other painters. However, Weber presided over his early development. Weber's stress on expression was the guiding principle. While many years later Rothko would repudiate self-expression as the proper function of art, during his formative years he drew upon that part of the modern tradition that stressed the reflection of individual personality. Through Weber he had learned to respect the direct expression of feelings evident in the work of the untutored and children. When he found a job in 1929 at the Center Academy in Brooklyn—a school for children run by a synagogue—he put his principles to work. Although friends sometimes point out that Rothko didn't like teaching, there is evidence that his work with children at the Center Academy was important to him. It enabled him to test his theory and reinforce his growing belief in art as man's expression of his total experience in the world. As he noted in a sketchbook of the mid-1930s, in which he was apparently preparing a speech to celebrate the tenth year of the Center Academy's art program, modern art had made the public aware of children's art by which they could learn "the difference between sheer skill and skill that is linked to spirit, expressiveness and personality." In a fragmentary sentence, he tried to be more specific: "Between the painter who paints well and the artist whose works breathe life and imagination." This rebellion against aca-

demic method reflected Rothko's earliest attitudes. In the older methods, Rothko noted, children were given examples and expected to perfect themselves in imitation of them. In his approach, "the result is a constant creative activity in which the child creates an entire child-like cosmology which expressed the infinitely varied and exciting world of a child's fancies and experience. . . ."

Rothko's serious study of the way children create and the great value he placed upon his teaching experience can be gauged by the careful notes he made during the more than twenty years he taught at Brooklyn's Center Academy. He conscientiously read the growing literature on art education and was familiar even with obscure sources. For instance, in an undated note he cited the pioneer Franz Cizek, a source that only a dedicated student of the psychology of art would have encountered.[6] Cizek had begun his experiments with children in Vienna in the late 19th century. In 1910 he organized classes for children from four to fourteen years in which they were free to work in many media and formats protected against "corrections" and "improvements." One of Cizek's maxims was "*Werden, wachsen, sich wollenden lassen*" (becoming, growing, achieving fulfillment). His work was presented at a congress in London in 1908 and thereafter gained currency in specialized English-speaking circles, and from 1920-22 an exhibition of works produced in his classes traveled in England and possibly in America. This might have come to Rothko's attention through subsequent discussions. In any case, his deep interest in what Cizek had called "the blooming and unfolding (Aufblühen un Entfalten) of the artist in the child" was certainly spurred by Rothko's need to understand his own impulse and to ponder the nature of art, as well as by his missionary character. Rothko's notes on child education are invariably fervent, filled with indignation at the insensitive general practises in art education, and generally reflect his need for a cause. Years later he would speak of abstract art in much the same way: as a cause.

It is not surprising that Rothko spoke of the "cosmology" of the child's world, or that he valued "spirit, expressiveness and personality." All through the 1920s theories of personality were discussed constantly. Freud's lectures in America in 1911 and his publication in English in 1915 of "On the Interpretation of Dreams" inspired

voluminous commentary. The Jazz Age took to Freud with alacrity. In Bohemian circles people analyzed each other constantly, and warned each other of the dangers of repression. Malcolm Cowley stresses the importance of the idea of "self-expression" during the 1920s in *Exile's Return* published in 1934. The concept of self-expression, he summed up as: "Each man's, each woman's purpose in life is to express himself, to realize his full individuality through creative work and beautiful living in beautiful surroundings." As a corollary, Cowley added, "Every law, convention or rule of art that prevents self-expression of the full enjoyment of the moment should be shattered and abolished. . . ." Rothko's interest in self-expression was perhaps shaded by his instinctive interest in finding an image of a whole, a "cosmology," but in his youth, expressiveness and what he called personality, seemed the highest values. In referring scornfully to "sheer skill," Rothko placed himself among the artists in New York's vanguard who had come to despise the empty technical feats of the American academic ranks—they were legion in those days—and who had also questioned the value of the elegant postwar European variations on early modern idioms. The results of French cuisine, as they slightingly referred to the masses of well-painted but decorative French works, were not for them. Nor were the clumsy works of the so-called regionalists very appealing. For Rothko and his friends, self-expression meant largely self-expressionism, and they looked not only to the German Expressionists and Soutine and Chagall, but also Rouault, whose somber watercolors seemed to fulfill demands both for expressivity and for skill.

In his late twenties, Rothko was beginning to seek principles which would help him to define his task as an artist. He was still moving fitfully in many directions and with considerable confusion when, after the initial meeting at the Opportunity Gallery with Milton Avery, he was brought to Avery's studio, probably by the musician Louis Kaufman who was a friend from Portland. Rothko's first encounter with a committed professional artist had been with Weber, an intense, voluble, and often bitter little man whose opinions were always emphatic. Weber wished to be a maestro. Avery, on the other hand, was exceedingly quiet, modest in appearance and gesture, and exuded calm confidence. He was then in his forties and

had been painting steadily for a number of years. He and his wife Sally, who was as exuberant as he was self-contained, lived modestly in a large one-room apartment where Avery got up every morning and painted, as he did in all the subsequent apartments the Averys maintained. The steady, unswerving devotion to his task that Avery showed Rothko was of inestimable value to the younger artist. He had been longing, from his early childhood, for a means to a total commitment. In Avery's way of living his life as a painter, Rothko found a mode. As he was to write after Avery's death, for the young who were questioning and "looking for an anchor," the admission to Avery's studio was to have "the feeling that one was in the presence of great events."[7] No doubt the cheerful family life of the Averys, whose home was always both a studio and a home, and the stability of the marriage appealed to Rothko. He was living then, according to Sally Avery, with Lou Harris on the Lower East Side in a tenement apartment with the toilet in the backyard. Crowded as it was, with a street life that never subsided, with cries of vendors, open markets, and hordes of children; with the din of Yiddish argument and eternal discussion, the Lower East Side contrasted sharply with the calm of Avery's studio. "I cannot tell you what it meant for us during those early years to be made welcome in those memorable studios on Broadway, 72nd Street and Columbus Avenue. . . . The instruction, the example, the nearness in the flesh of this marvelous man—all this was a significant fact—one which I shall never forget."

What Rothko perceived in Avery was his "naturalness" and his quiet poetry. No doubt he valued the naturalness, "that exactness and that inevitable completeness which can be achieved only by those gifted with magical means" because he himself was still so much a novice, and still trying so hard to find pictorial means to express his own poetry. He admired Avery's simple approach to the subjects of his paintings, drawn as they were from "his living room, Central Park, his wife Sally, his daughter March, the beaches and mountains where they summered; cows, fish heads, the flight of birds; his friends and whatever world strayed through his studio: a domestic, unheroic cast." Rothko could address himself only with the greatest difficulty to the modest and domestic. Much as he

longed to, and much as he appreciated Avery's ability to live within the terms of the perceived world, there was, in him, a strong pull toward the cosmic and heroic. All the same, the salubrious environment of Avery's studio where he was always welcome, and Avery's own canvases, inspired him. Rothko diversified his work from the moment he began frequenting Avery.

Avery himself had not yet found the harmonious condensations that appeared in later work. His drawings tended toward a kind of illustrator's literalness, with awkward cross-hatching. His paintings, though, already evidenced his interest in expressing his subject through suggestive color harmonies and simplification of gesture. He foreshortened or elongated figures, sometimes stressing the thrust of a limb, or the tilt of a head by means of gentle distortion. For Rothko, Avery's generalizing of such irking details as fingers and feet would have been a blessing, as he had not had the long training in drawing of the average art student. Avery's reclining figures on the beach, or his child portraits, displayed a tenderness that Rothko valued highly. Rothko's watercolors and gouaches, once he met Avery, begin to show a clarification of purpose. He was working hard to fulfill an intense desire to establish a prevailing mood. Distortions similar to Avery's, such as making large bodies with small heads, or small heads on large bodies, appear around 1930. Increasingly Rothko strived to compose appropriate settings. His colors were often muted, with terra-cottas and whitened browns and grays as in certain Avery paintings of the early 1930s.

Around the same time Rothko began to see a lot of Adolph Gottlieb, a painter his own age who had had the good fortune to wander in Europe while a student. Gottlieb's temperament was less romantic, perhaps, but he shared with Rothko an intense interest in finding an expressive language of his own. Unlike Rothko, he did not think of himself as a born anarchist, although he was quick to challenge authority. They had met at the Art Center Gallery, one of the very few small galleries that introduced new artists, and later at the Opportunity Gallery where Rothko had first showed, and where each month a well-known artist presented new young artists. Gottlieb remembers Kuniyoshi and Alexander Brooke as selectors and that "Mark and I and Milton Avery frequently got into those

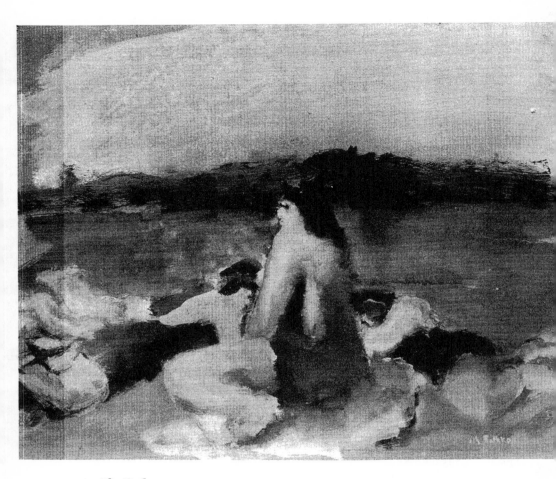

5. *The Bathers* c.1930

shows."[8] Gottlieb and Rothko's friend Lou Harris, began to make Avery's home an almost daily meeting place. Sally Avery remembers long evening conversations, and animated discussions about the paintings on the Averys' wall. Rothko was "very verbal and told fabulous stories, a continual raconteur."[9] Although Avery was more than eighteen years older, he readily allied himself with his two young admirers, and submitted to their criticisms of his work. This shared experience seemed to buttress Rothko's confidence. He and Gottlieb continued the pattern for years, even joining the Averys summers for vacations. They would paint furiously during the day and then compare works. The long evenings were spent in discussions, often of literature—poets such as T. S. Eliot and Wallace Stevens—and, according to Sally Avery, some philosophy. Rothko, she says, was reading Plato.

Both Rothko and Gottlieb had a great need to talk and would meet frequently. "Rothko was one of the few guys who were articulate," Gottlieb recalled, "because in those days painters were sort of silent men." No doubt they talked about the works they saw in the newly opened Museum of Modern Art, and they talked about the distasteful, chauvinistic art critics who fulminated against "foreign" influences in American art, stridently calling for an American art that the man in the street could identify with. The American Scene painters were very much on the scene. One of them, Thomas Hart Benton, converted from abstraction and took up the banner of Americanism. He attacked European sources and, as he wrote shortly after, at the height of the Depression, he separated American art "from the hothouse atmospheres of an imported, and, for our country, functionless aesthetics." He went on to speak of "releasing American art from its subservience to borrowed forms."[10] Neither Rothko nor Gottlieb could accept such rhetoric, although they, like many others, were watching social and political events in America with great attention and spent many hours discussing the national crisis initiated by the crash in 1929. During the early 1930s Rothko and Gottlieb were more aware of what they refused than satisfied with what they themselves undertook. They refused American regionalism, Cubist decoration, total abstraction, and the sharp realism of the New Objectivity. They were still moved by moody Euro-

pean Expressionism, but had been smitten with Avery's version of the rhapsodic art of Matisse. They exposed themselves to many kinds of painting, and occasionally the distinct impact of one or another modern (or sometimes not so modern, as in the case of El Greco elongations, or light effects of Corot) could be seen in their work. They read the prominent art journals of the day and scanned the reproductions. In *Creative Art* in 1931 and 1932, for instance, they could become acquainted with reproductions of recent work by Max Beckmann, Picasso, Derain, and the French Surrealists. At the time there were also articles about the Italian painters of the *Valori Plastici* group—those who had programmatically renounced abstract art—and the *scuola metafisica*. Reproductions of de Chirico appeared fairly often in art periodicals, and also of Carrà. The somewhat softer metaphysical paintings of Carrà may have attracted Rothko. In one of his gouaches dating back to the late 1920s or early 1930s, there is an enigmatic juxtaposition of a large almost triangular head with painted head just behind it, its features rendered much in the stylized Carrà manner. There are also still-lifes and street scenes in which the whitened tones of some of the Italians, among them, Morandi and de Pisis, appear. For artists in the late 1920s and early 1930s, the various postwar Italian idioms may have seemed an ideal compromise between the radical modernism of the non-objective painters and the stultifying naturalism of the painters of the American Scene School.

In 1932 Rothko married Edith Sachar, a young jewelry designer who managed to make a living even during those difficult days. They lived near the Averys although the new young wife was apparently resistant to Avery's influence. Rothko had his first one-man show the following summer at the Portland Museum, where he took the unusual step of showing his own work along with works by the children in his classes at the Center Academy. It was clear that he believed wholeheartedly in the values inherent in the work of the uncorrupted. Child art, for Rothko, was a touchstone, a kind of barometer of truth. In this he may well have been encouraged by J. B. Neumann, whose advice and approval Rothko valued. Several of the children's drawings in the exhibition were in the collection of Mrs. Neumann. Rothko himself showed watercolors and drawings.

The critic for the *Oregonian* wrote approvingly (July 30, 1933) of a strong Cézanne influence. Rothko had painted a group of watercolors with the rationalized planes and spareness associated with Cézanne, but, as Diane Waldman has pointed out, these may well have been youthful imitations of work he had seen by John Marin. More likely, they were paraphrases of Avery's system, itself derived from Cézanne. The following November, Rothko had his first one-man show in New York at the Contemporary Arts Gallery. The exhibition included oils, watercolors, and drawings, and must have spanned several years. A critic in *Contemporary Arts* discussed one painting, "The Nude," remarking on its "ponderous structure" that harks back to the "Eight Figures" by Max Weber. But the critic also noticed the Cézanne influence. There were probably other influences as well. Between 1930 and 1933 Rothko had been emboldened to try more complex compositions, sometimes with several figures. Matisse's voice, filtered through Avery, is faintly heard in some of the paintings referring to music. There is one painting of a group of figures listening to a pianist in which a bright blue rug is painted parallel to the picture plane, and a geometric element—a square—used to balance the composition. On the other hand, there is an oil on masonite painting of a string quartet in which somber blues and browns predominate and the heads are rendered in ghostly gray tones, indicating Rothko's express wish to convey his feelings about the music. In the street scenes, Rothko used architectural settings to enhance a vision of urban isolation and loneliness. The theatrical effect is apparent, with scenes brought close to, and parallel with, the picture plane and backgrounds seeming like theater flats. In one, two women and a child are centered in the foreground flanked by two long narrow niche-like windows in which elongated robed mannequins are indicated. Still bolder is a painting that must have arrived after one of his forays in the Metropolitan Museum. This small painting on masonite seems to be an interpretation of a Renaissance interior. It is composed in two tiers, with an ambiguous portrait, perhaps of a cardinal, dominating its center and two apparitional marble sculptures flanking its lower portal. Three darkly scumbled figures are in the doorway. A drama is suggested here, and Rothko depended on the sketchy ambiguities in his brushwork to

6. Untitled c.1932

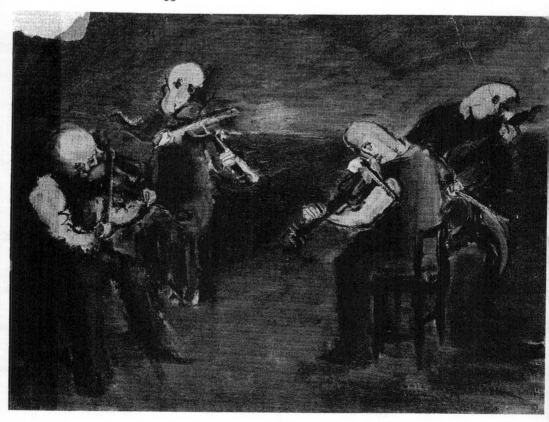

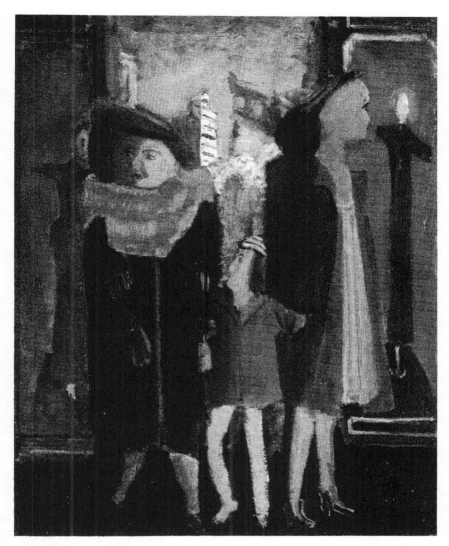

7. Untitled c.1933

reinforce the dramatic theme. While the flatness reminds us of his modern preoccupations, the color—oxblood above, green and dark brown below—and atmosphere remind us that Rothko was an admirer of Rembrandt and Rouault.

While Rothko was struggling to find his voice, there were serious distractions. The entire artistic community was beginning to feel the strain of the Depression. In the neighborhoods that many painters inhabited in New York there were unmistakable signs of the débacle: breadlines, apple sellers, and soapbox orators. All America was discussing the unprecedented economic collapse. The atmosphere of emergency sponsored unusual attitudes and opened America to a frantic debate. Probably the crisis rekindled Rothko's political energies, although he had already decided that his first commitment was to art. He and his friends were aware not only of the domestic disaster but of sinister developments on a world scale. All during the 1930s there was plenty to worry about: the consolidation of Mussolini's power; the rise of the Nazis; Italy's conquest of Ethiopia; the 1936 outbreak of the Spanish Civil War, and Hitler's arming of the Rhineland; the Moscow trials in 1937; Hitler's annexation of Austria and his occupation of Czechoslovakia. On the personal level, there was imminent starvation, even for the resourceful Bohemians who found themselves, in 1934, without means. There were also grave threats to civil liberties. In 1934 an event occurred that roused the artists to action: Diego Rivera, much admired at the time, had completed his murals for Rockefeller Center. When the Rockefellers discovered that he had portrayed Lenin, they ordered the murals destroyed. Agents arrived on the site where Rivera was putting the finishing touches and ordered him off the scaffold. A few assistants present ran to telephones to alert other artists, and a large group including Rothko assembled to protest. They tried, unsuccessfully, to block the demolition of the work. Out of this dramatic night's gathering grew the Artists' Committee of Action. At the same time militant artists who foresaw even more dire consequences of the Depression had managed to organize the Artists' Union at a large meeting attended by Rothko and Gottlieb, among some two hundred others. The Artists' Union's purpose was "to unite artists in the struggle for economic security and to encourage wider distribution

and understanding of art." There is every reason to believe that Rothko's old commitment to "one big union" was bestirred. He was present at the Union's monthly meetings, and when the publication *Art Front* began in November 1934 he was active among its supporters. Among the letters published in the first issue encouraging the editors was one from Lewis Mumford praising the fight for a municipal art gallery "because it will help take art out of the sphere of mere connoisseurship and wealthy patronage," and one from Max Weber, whose presence in Rothko's artistic life was still evident. Weber wrote, "My heart is full; welled to the brim with resentment for I see clearly—as other artists who are socially conscious—how Nazism, chauvinism and fascism are worming into the life of art and artists. . . ."

The Artists' Union was demanding government projects that would be more effective than those of the newly established Public Works Administration, with "complete freedom in the conception and execution of work." Rothko was active in demanding the municipal gallery, and in struggling with the forces in the Artists' Union that mistook provincialism for a new brand of American art. No doubt he experienced the chaotic political events intensely, and, like so many others, hesitated before their enormities. Both Juliette Hays, wife of the writer H. R. Hays, and Joseph Liss, a writer interested in theater, who had met Rothko around 1935, remember Rothko's intense concern with the political situation. There were long and heated discussions in which Rothko expressed his conflict about taking positions. As an artist he felt reluctant to join any groups, but as an individual concerned with social justice, he felt obliged to support group activities. Aesthetically he was clear: he loathed every thing that smacked of social realism; fulminated against such favored figures as Joe Jones and William Gropper, whom he regarded as little better than cartoonists. Although the long evenings of discussion often veered to politics, Rothko, "who liked to probe a situation looking at it in many ways" according to Liss, liked best to talk about painting. He was, in those days, open to all kinds of aesthetic experience, according to Mrs. Hays, and thought of himself as a vanguard artist. The elaborate conversations, she reports, wandered throughout art history, and Rothko's "fertile

mind" was always at work. "He was ebullient. He was a real force." Mrs. Hays points out that in those days, Rothko had a great sense of humor and when the spirit took him, would parody the sentimental poetry of Edna Saint Vincent Millay by translating it into Yiddish. Liss, who like Rothko was Russian-born, remembered "kidding around" in Russian. In politics, he says, Rothko was avant-gardish—more "an Art for Art's Sake type." Few artists could resist the need to make a statement reflecting the times, and Rothko, while he was apparently convinced about the separation of civic life and art, nonetheless adopted themes that were common to the epoch. His anarchist instincts protected him from succumbing to the vast surge toward social realism. Freedom of expression was after all the rallying cry of the old anarchists. But the need to reflect on the melancholy, even dangerous state of affairs was there, and crept into his work between 1934 and 1938.

As hectic as was the public life of most artists during the worst of the Depression there was paradoxically a suddenly rich artistic life as well. For Rothko there were to be many small exhibitions, and an increasing circle of artist friends sharing his attitudes. Moreover there were exhibitions that bolstered his innate distaste for the new social realism and regionalism. Julien Levy had opened his gallery, bringing in exhibitions of the Surrealists, first a group show and then a one-man show of Dalí to which Rothko responded enthusiastically. The second issue of *Art Front*, in January 1935, included a review by the erstwhile Russian painter John Graham warmly commending the gallery and saying of Surrealism that

> it is, as all abstract art, truly revolutionary, since it teaches the unconscious mind—by means of transposition—revolutionary methods, thus providing the conscious mind itself with material and necessity for arriving at revolutionary conclusions. . . . Those who think abstract art is just a passing phase are mistaken. Rivers do not flow backward.

In the same issue Stuart Davis, extremely active in the Artists' Union, and regarded as a left-wing militant by most other artists, reviewed the Dalí exhibition with astute appreciation. Subsequent issues contained lively debates between avowed Marxists, eager to maintain social content in visual art, and independent artists attack-

ing the American scene painters and narrow visions in general. The ferment was rapid. Numerous arguments punctuated artistic life. The struggle to dominate *Art Front* saw almost monthly upheavals with which Rothko was thoroughly au courant. Early in 1934, he had become friendly with Joseph Solman who was to lead a protest a few months later initiated by several progressive artists, among them Rothko, against what they felt to be the narrowly economic and social interest of the publication. Rothko's work appeared in several group exhibitions, among them one at the newly opened Gallery Secession (an overt allusion to the expressionist bent of its exhibition policy). Among the artists in the first exhibition, in December 1934, were Ben-Zion, Ilya Bolotowsky, Louis Harris, Rothko, Gottlieb, Solman, and Nahum Tschacbasov. The convergence of these artists, several of whom were Russian born and most Jewish, indicates that Rothko still moved in the circles where he felt comfortable and familiar, and that his aesthetic remained largely within the principles set out by Weber, although he was already beginning to ponder other questions. Ben-Zion, for instance, was deeply committed to the Jewish experience and painted tableaux from the Old Testament, especially solemn patriarchs whose symbolized gestures were stressed in skillful exaggeration of hands. (Rothko perhaps was tempted by these hands, for in several of his subsequent semi-abstract paintings, the hieratic gestures of Ben-Zion's prophets appear with similarly drawn hands.) Tschacbasov also dealt with Jewish themes, and had been visibly influenced both by early Chagall and by the Burliuk brothers' primitivism.

"Somewhere around 1935," Gottlieb recalled, "we formed The Ten. We were outcasts—roughly expressionist painters. We were not acceptable to most dealers and collectors. We banded together for the purpose of mutual support."[11] The initial group came together in the Gallery Secession exhibition and then decided to form its own exhibiting society, hoping to persuade different galleries to hold their shows. They managed to show frequently for five years. As a group they fluctuated, although Rothko, Gottlieb, Harris, and Solman were constant. In recalling the years of The Ten several of its members have noted the importance of the monthly meetings in each other's homes, where discussions grew heated and lasted

through the night. Rothko was one of the most enthusiastic partici-
pants, and loved to follow labyrinthine paths in argument. Subjects
varied, but certainly the strangely heightened years of the 1930s
brought extremely varied issues to the fore. A great deal of the dis-
cussion was devoted to the perplexing artistic issues emerging
within the troubled world context. Rothko seemed clear about his
commitment to modern art, and also to certain artists of the past
(Solman remembers Rembrandt, Bellini, and Corot). The entire
group, who regarded themselves as "progressives," were keen fol-
lowers of the news from Europe—the latest works of Picasso, Matisse,
Rouault, and the German Expressionists. They paid close attention
to the exciting exhibitions at the Museum of Modern Art, particu-
larly the *Surrealism and Dada* show in 1936. They maneuvered
among conflicting directions, trying to find a middle ground be-
tween the extremes of social realism and abstraction. "The whole
problem seemed to be how to get out of these traps—Picasso and
Surrealism—and how to stay clear of American provincialism, Re-
gionalism and Social Realism," according to Gottlieb. For a time,
Art Front stimulated wide-ranging discussions, having been re-
buked by Solman—who represented, among others, Rothko, Bolo-
towsky, Balcomb Greene, and George McNeil—with a manifesto
complaining that the editors were unaware of the educational value
of the Museum of Modern Art, and that the magazine should look
like an art magazine and not only a union newsheet.[12] Solman was
soon invited to the editorial board and initiated a lively program.
One of his first acts was to publish in the December 1935 issue a
lecture given by Fernand Léger at the Museum of Modern Art. Al-
most certainly this lecture had been one of the hot topics at the
monthly meetings of The Ten. Léger began by summing up the past
fifty years as a struggle of artists to free themselves from old bonds,
particularly the restraint of subject matter. The Impressionists, he
said, had freed color, and "we have carried the attempt forward and
freed form and design." He declared that subject matter was at last
"done for" and stated categorically "that color has a reality in itself,
a life of its own; that a geometric form has also a reality in itself,
independent and plastic." Perhaps Rothko pondered Léger's central
statement that the ridiculous question "What does that represent"
was no longer relevant:

> There was never any question in plastic art, in poetry, in music of representing anything. It is a matter of making something beautiful, moving or dramatic—this is by no means the same thing.

This lecture was translated by Harold Rosenberg, whose own anarchistic instincts led him into battle with the *Art Front* executive board. They soon pushed him out.

The Ten meanwhile arranged their first group show at the Montross Gallery in December-January 1935-36, and a few weeks later they were part of the opening exhibition at the much fought-for—and won—Municipal Art Gallery, where all of the participants had demonstrated noisily for a revocation of the Gallery's Alien Clause, which stipulated that only citizens could exhibit there. A few months later The Ten had an unprecedented stroke of luck: they were invited by Joseph Brummer to exhibit in France. For "progressives," this was an exceptionally exciting opportunity to repudiate the rising nationalistic clamor in the ranks of the artists (some of whom were at work, along with Rothko, in the easel division of the WPA). The exhibition at the Galerie Bonaparte in November 1936 was introduced by a well-known Paris critic, Waldemar George, who noted that Rothko, in his "Crucifixion," revealed his nostalgia for masters of the Italian Trecento. A critic reviewing the exhibition felt that all the members had been influenced by Picasso and Rouault, and that Rothko's paintings "display an authentic coloristic value."

The attention paid to their public exhibiting life did not inhibit The Ten from performing volubly at Artists' Union meetings. They were active in preparation for the American Artists' Congress announced for 1936 by Stuart Davis in *Art Front*, December 1935, who gave as the objectives

> to point to the threat of the destruction of culture by fascism and war; to point out specific manifestations of this threat in this country; to show the actual accomplishment of such destruction in those countries where fascism holds power; to show the historical reasons for fascism, and to clarify by discussion what the artists must do to combat those threats.

But, Davis insisted,

The objectives of the Congress are not only defensive. A prominent part in this discussion will be given to an analysis of contemporary art directions; to the historical role of the artist in society; to the relation of subject and form in art to environment. . . .

The Ten could readily support the Congress's goals and were enthusiastically present when the three-day session opened in February 1936. Rothko, who was sensitive to world developments from his early youth and anxious at all times about 20th-century excesses, certainly had caught the prophetic overtones of Lewis Mumford's opening address in which Mumford stated:

> The forces that are bringing on war, that are preparing for larger and better economic depressions in the future, are at odds with the forces of human culture. The time has come for the people who love life and culture to form a united front against them, to be ready to protect, and gauge, and if necessary, fight for the human heritage which we, as artists, embody.

3

When the easel division of the WPA was fully under way, scores of artists in New York lined up for their monthly paychecks, or checked into headquarters, and were drawn into conversation with their colleagues. The isolation of the past, in which so many artists had languished or fallen by the wayside, gave way to a new and turbulent situation. Artists of various persuasions were thrown together and forced, by circumstance, to wrestle with urgent questions, both social and aesthetic. The Ten broadened their associations. Still, they remained a unit that represented a distinct point of view. Decades later Willem de Kooning, also on the easel project, remembered Solman and Rothko, and their vigorous claims for Expressionism. With so much hectic discussion, and much foregathering, it was inevitable that thoughtful artists undertook to sort out their views. Rothko, who was on the project for the year 1936, during which time the Museum of Modern Art staged the "Fantastic Art, Dada, Surrealism" exhibition, had not moved significantly in his painting, but was beginning to draw together the threads of his diffuse thoughts on the meaning of art. He still maintained, as he later observed about children's art in his mid thirties sketchbook, that mere skill was meaningless unless it served to express spirit and personality. But he was beginning to reflect with more assurance on the various theories put forward by modernists. Léger's statement—that modern art had gotten rid of subject matter—was emphatically re-

jected. Years later, when Rothko was already an abstract artist, he still resisted non-objective theory, vehemently stating, "I would sooner confer anthropomorphic attributes upon a stone than dehumanize the slightest possibility of consciousness."[13] The Expressionists, who regarded themselves as legitimately ensconced in the radical modern aesthetic tradition, also had to face the more adamant claims of the newly formed group, the American Abstract Artists, who organized in the fall of 1936, modeling themselves on comparable groups in Europe: the English "Circle" group and the French "Cercle et Carré." These artists, a number of whom were on the WPA, proposed to unite American "abstract" artists in order to call attention to "this direction in painting and sculpture." In their general prospectus published in 1937 they were careful to state, "we place a liberal interpretation upon the word 'abstract'," thus allowing such varied artists as Ibram Lassaw, Byron Browne, George McNeil, George L. K. Morris, Ilya Bolotowsky (still showing with The Ten), Alice Trumbull Mason, Giorgio Cavallon, and Josef Albers to participate. All the same, as Lee Krasner remembers, "they had a little purist academy of their own."[14] The strong thrust of those who had received and accepted the non-objective tradition of Mondrian soon brought them into dominance in the organization. The Ten, with their conception of an expressive art epitomizing life, could pit themselves against such theories with fervor, although the prevalence of social realism seemed far more despicable to them. Rothko probably wrote or at least formulated the statement for The Ten's exhibition in protest to the Whitney Museum's policy in November 1938. The exhibition, called *Whitney Dissenters*, would fight "a new academy" that

> is playing the old comedy of attempting to create something by naming it. Apparently the effort enjoys a certain popular success, since the public is beginning to recognize an "American" art that is determined by non-aesthetic standards—geographical, ethereal, moral or narrative.

Rothko characterized his group as

> homogeneous in their consistent opposition to conservatism; in their capacity to see objects and events as though for the first

time, free from the accretions of habit and divorced from the conventions of 1,000 years of painting.

The clue to Rothko's preoccupations lies in the phrase "their capacity to see objects and events as though for the first time." Although his work, and that of his confreres in The Ten was still attached to sometimes sentimental themes—the *Sehnsucht* of the romantic Expressionists—he was already pondering the lessons of the Surrealists. In February 1937 the painter Jacob Kainen, who wrote criticism for Art Front and was friendly with the group, had praised an exhibition of The Ten, noting that they attempted to reduce the interpretation of nature or life in general to the rawest emotional elements; had a complete and utter dependence on pigment; and showed an intensity of vision. Of Gottlieb and Rothko, he had praise for their "usual sober plasticity, keeping everything simply emotional." Significantly, Kainen linked Expressionism with the mounting fear of war, warning "we are closer to chaos than we think." Barely a year later, Rothko was writing of seeing everything for the first time, free from the accretions of habit. Like Kainen, he was sensitive to the world situation and felt the chaos descending. His work of the late 1930s reflects his preoccupations: an increasing need to find the pictorial language to express his intimations of disaster; his increasing preoccupation with the life cycle, and above all, his growing awareness of the tragic, in which death is an acknowledged actor.

Nearly all the "progressives" among New York's painters had been startled and unsettled by the Surrealist exhibitions at Julien Levy's gallery, and the Museum of Modern Art. They responded according to their temperaments. Rothko seemed most affected by the Surrealist displacement of time; its long prospects in which the life of the spirit, or mind, could reach back to millennial visions; to origins in which everything was new, fresh, authentic. The Surrealist reverence for myth, in which the commentary on existence is for all time, and presents simultaneities of time, satisfied Rothko's craving for release from the quotidian; his instinctive drive to free himself from the shibboleths of contemporaneity and to be mobile, as he said his children students were, in the realm of the imagination where there could be "an entire cosmology." In his middle thirties, Rothko was ready to shape his visions of forlornness, and the tragic, on grand and

sober lines. The resurrection of myth during the late 1930s, experienced by many artists, was to have special consequences for him.

The Surrealists were not the only ones to appropriate ancient myths as a new framework for artistic discourse. The plasticity of the word "myth" allowed for considerable latitude in interpretation. The Marxists among the artists, for instance, had a fondness for the word. Marxist literary critic A. L. Lloyd, for instance, woefully twists and turns with the notion of myth, in "Modern Art and Modern Society" published in *Art Front* in October 1937:

> The bourgeois artist finds no theme he can acknowledge as valid. . . . This curious circumstance is largely due to the historic decay of myth, and it is the decay which has so materially contributed towards widening the gap between economic and spiritual production. . . . As Marx pointed out, the role of myth is to express the forces of nature in the imagination. . . . Only an autochthonous mythology, a mythology coming from the same soil, the same people, the same cultural superstructure of the same economic order can be an effective intermediary between art and material production, despite the bourgeois superstition that any mythology, even one personally transformed into a kind of private religion, can form such a link. . . .

To this, such self-styled anarchists as Rothko and Barnett Newman (whom Rothko began to see frequently during the late 1930s) responded with derision. For them, the realm of the mythic knew no "autochthonous" bounds. Other sources for the mythic approach to human history were more congenial. There was considerable discussion of the works of T. S. Eliot during the 1930s. Eliot was one of the authors Sally Avery recalls as having been read and discussed during the summer evenings when the Rothkos, Averys, and Gottliebs vacationed. Eliot was unpopular with the Marxists, who regarded his disdain for historical materialism as reactionary. But the artists in Rothko's circle were strongly attracted to Eliot's anti-historical critique implicit in "The Waste Land." It is quite possible that Rothko's enthusiasm for Frazer's *The Golden Bough* derived from his close reading of Eliot, who referred his readers in his notes to the anthropological classic. Eliot was aware of the needs from which his use of Frazer derived, as can be seen by his comment on James Joyce, whose *Ulysses* had appeared in 1922, the same year as

"The Waste Land." "In using the myth, in manipulating a continuous parallel between contemporaneity and antiquity, Mr. Joyce is pursuing a method which others must pursue after him. . . . It is simply a way of controlling, of ordering, of giving a shape and a significance of the immense panorama of futility and anarchy which is contemporary history."[15] Eliot's estimation of Frazer's importance was again stated in *Vanity Fair*, in February 1924, when he said that Frazer "has extended the consciousness of the human mind into as dark and backward an abysm of time as has yet been explored." Both *The Dial* and *Vanity Fair* were read by artists in Rothko's circle. What Rothko needed was not the literary allusions so much as a new way, as Eliot said, of controlling and ordering his experience in a time he found out of joint. For him, the atmosphere of removal was essential in order to formulate his point of view of existence. The myth for Rothko was, and remained, the source of a dramatic confrontation between nature, ruled by law, and the human imagination, free in its expression. His appropriation of myth sometime in the late 1930s derived from a need identical with Eliot's and Joyce's. He found in myth what Ernst Cassirer described as "a dramatic world of actions, of forces, of conflicting powers."[16] In every phenomenon of nature, Cassirer writes, the mythic world

> sees the collision of these powers. Mythical perception is always impregnated with these emotional qualities. Whatever is seen or felt is surrounded by a special atmosphere—an atmosphere of joy or grief, of anguish, of excitement, of exultation or depression.

Interestingly, Cassirer looked to the American philosopher John Dewey, for support of his argument. Dewey published *Experience and Nature* in 1925, and *Art as Experience* in 1934. Both books were widely discussed among American artists—far more than is generally conceded. Cassirer, citing the 1925 book, maintains that Dewey was the first to recognize and to emphasize the relative right of those feeling-qualities which prove their full power in mythical perception. He quotes Dewey:

> Empirically, things are poignant, tragic, beautiful, humourous, settled, disturbed, comfortable, annoying, barren, harsh, consoling, splendid, fearful; as such immediately and in their own right and behalf.

In *Art as Experience*, as William Seitz pointed out after extensive conversations with Rothko and other Abstract Expressionists, Dewey maintained:

> If the artist does not perfect a new vision in his process of doing, he acts mechanically and repeats some old model fixed like a blueprint in his mind . . . the real work of an artist is to build up an experience that is coherent in perception while moving with constant change in its development.

What Cassirer calls "feeling-qualities" became more and more important to Rothko, whose emotional life had thrust him from subject to subject and technique to technique without ever providing satisfaction. Painting was his only means, and it always fell short. Often he wistfully compared painting to poetry or to music, and with an uneasy sense of his own inadequacy. It was not only the "poignant"—a favorite word—that he sought to express. He also harbored a deep need to discover in the world, and therefore in his "self," the heroic—a quality of which the modern world seemed bereft; a quality perhaps impossible to achieve ever again. From the late 1930s through the 1940s, Rothko was preoccupied with the personal archaeology that would reach deep into what Eliot called the abysm. As he wandered toward his "self" he instinctively returned to what his complex temperament could thrive on. At once tender and impatient, profoundly in need of a framework that could contain his passion, he cast himself back to an era of sober grandeur. He read the ancient Greeks, above all, Aeschylus. The importance of Aeschylus in his psychological evolution is indisputable. In countless conversations, once in public forum, and in writing Rothko invoked Aeschylus (along with Shakespeare sometimes). Several of the important paintings of his so-called Surrealist period were based on the Agamemnon trilogy.

There are many reasons why, at a certain moment, a condition of acute sensibility and susceptibility to certain works of art arrives. These reasons are suffused throughout an artist's inner life and can only be faintly determined. When Rothko returned to the Greek tragedies, the circumstances, the state of the world to which he was never insensible, were as menacing as in ancient times. The blood that had flowed unstanched during the Spanish Civil War presaged

the Hitlerian Holocaust. Artists, or at least certain artists, had dreaded a cataclysmic future for more than a decade already. Rothko's early efforts had been to convey largely melancholy responses to the human situation. Yet, the need for a loftier, somewhat more remote inspection was always there. Perhaps his early training, with its emphasis on the Law and Jewish fate, and its exposure to the stately poetry of the Old Testament, readied him for his profoundly moving encounter, sometime in the very late 1930s, with King Agamemnon. How was any sensitive artist to comprehend the dimensions of destruction encompassing the Western world in those days? Aeschylus, whose meditation on war and death in the Agamemnon trilogy was measured but passionate and whose understanding of human frailty was sutble, had found a form, or rather, a structure. The containment that so much enhanced the drama, was probably what Rothko recognized, finally, as a possible answer to his own artistic dilemma. Many years later Rothko would speak of "a clear preoccupation with death—all art deals with intimations of mortality." In Aeschylus, death takes its place as a *persona*, acted upon and acting, in a total drama.

Rothko was not a literary critic or an anthropologist or a psychoanalyst or a classicist. He read his Aeschylus not from a need to know but from a need to be moved. The "poetic"—which is to say the diction that Aeschylus and no other chose—is what moored itself in Rothko, enabling him to draw upon it as he undertook to work out his own destiny as a creator. Early in the drama, as the chorus files out before the palace of King Agamemnon to recite the woes that had overtaken the house of Atreidae ten years before, the very first image strikes to the heart—an image Rothko was to use in many works from 1939 to 1947:

> Their cry of war went shrill from the heart,
> as eagles stricken in agony
> for young perished, high from the nest
> eddy and circle
> to bend and sweep of the wings' stroke,
> lost far below
> the fledgings, the nest, and the tendance.

Translated by Richmond Lattimore

The pathos of the mighty eagle insulted is likened by Aeschylus in the conclusion of the same speech to the fateful condition of man who, "leaf withered with age / goes three footed / no stronger than a child is, / a dream that falters in daylight." Aeschylus' guarded critique of the gods addressed itself to Rothko who had early learned the significance of suffering. In declaring his Russianness, he betrayed his attachment to the Aeschylean notion that Zeus, who guided men to think, "has laid it down that wisdom comes alone through suffering" and that, as the chorus intones,

> From the gods who sit in grandeur
> grace comes somehow violent.

Not so different from the portentous passages in the Old Testament is the chorus's heart-rending reminiscence of Agamemnon's murder of Iphegenia, "lovely as in a painted scene, and striving to speak," and its conclusion that

> Justice so moves that those only learn
> who suffer; and the future
> you shall know when it has come; before then, forget it.
> It is grief too soon given.

Rothko, harking back to the violence from which he had shrunk as a child, and which he abhorred as a man, wished to find the poetic equivalent of his sentiments on the eve of the Second World War. Aeschylus more than any other knew the perfidy of "the god of war, money changer of dead bodies" who sent young soldiers back, "packing smooth the urns with ashes that once were men" and who expected the bereaved to praise him through their tears. But, Aeschylus knew, the people "mutter in secrecy, and the slow anger creeps below their grief." The undertones in Aeschylus are born in images, very often the image of the bird, with which the chorus began. Toward the end of the tragedy the chorus asks

> Why must this persistent fear
> beat its wings so ceaselessly
> and so close against my mantic heart?

And Cassandra, on the brink of her fate, laments

> Oh for the nightingale's pure song and a fate like hers.
> With fashion of beating wings the gods clothed her about
> and a sweet life gave her and without lamentation.

As she goes to her death, Cassandra addresses the chorus:

> Ah friends,
> truly this is no wild bird fluttering at a bush,
> nor vain my speech.

Finally, Clytemnestra's cry, "Oh, it is sweet to escape from all necessity!" lingered in Rothko's imagination, together with the Aeschylean warning that such a situation is against nature.

Resounding tragedy in the high poetic tone of the Old Testament, whose stately rhythms were early instilled in Rothko, aroused him. Just as Mozart, in *Don Giovanni* and *The Magic Flute,* to which Rothko always thrilled, could sound grand, tragic notes with an august finality while yet preserving delicate nuances, the small touches and images in Aeschylus that lighten but do not banish the underlying tragedy stirred him. If birds' wings flutter either wildly toward freedom or in a panic of fateful recognition, they are the birds of Greek and Old Testament configuration—images of the soul; stand-ins for the invisible, unpredictable resources of men; embodiments of dreams of freedom, and dreams of wholeness, as, in their roundness, as Gaston Bachelard poetically insisted, they are cosmos. These birds are not exactly the symbols, with their violent connotations, fetched up by the Surrealists from Freudian depths. Not, at any rate, for Rothko who eventually abjured their visible shape and reverted to ancient images, or "feeling-qualities," that stood for cosmos.

Rothko arrived at a semblance of assurance in wielding myth and was able to indicate clearly the way he thought of it in his statement accompanying the reproduction of "The Omen of the Eagle," 1942:[17]

> The theme here is derived from the Agamemnon Trilogy of Aeschylus. The picture deals not with the particular anecdote, but rather with the Spirit of Myth, which is generic to all myths of all times. It involves a pantheism in which man, bird, beast and tree—the known as well as the knowable—merge into a single tragic idea.

His way to the "single tragic idea," which was to remain his most persistent quest, was neither direct nor easy. At first, around 1938, he seemed to seek to transform the visible and present into the "Spirit of Myth" which he felt to be direct and unmediated. What

8. *The Omen of the Eagle* 1942

9. *Subway (Subterranean Fantasy)* c.1938

10. Untitled c.1936

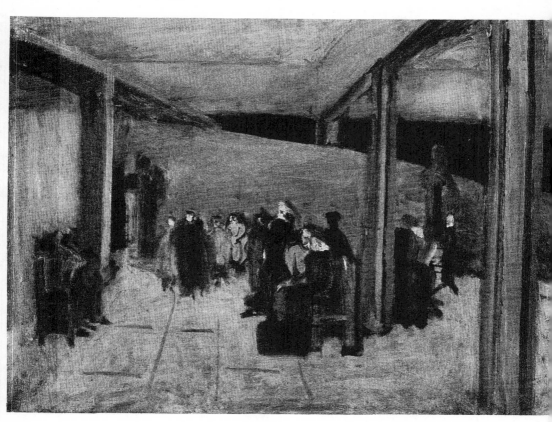

11. *Subway Scene* 1938

he admired in Avery—the poetic directness—was still elusive in his own work. Tragedy and human fate certainly underlay his approach to the subway scenes in the late 1930s (a common enough motif among urban realists) in which he adopted various stylistic simplifications in order to stress the broader drama of individual isolation. Perhaps his Russianness—what he thought of as his Russianness: his melancholy and his moodiness—invaded his soul as he grappled with the problem of individual destiny. Perhaps he remembered Dostoyevsky's warnings in so many of his stories and novels that utter isolation leads to madness and tragedy. Yet, how could an artist, an underground man, circumvent it? In any case, Rothko's series of subway scenes were fraught with foreboding, and some have seen the beginning of his mythic explorations in them. Here are the beginnings of an Orphic descent. In what is probably the earliest scene, the figures are dwarfed by a cavernous no-man's-land, grouped as they might be on a stage, and dimly picked out with a memory of Rembrandt and Rouault, in what one critic called the "dirty expressionist" style. In two other versions, dated between 1936 and 1938, Rothko strives to impose a distanced vision of souls isolated in a silent netherworld punctuated with subway columns that are like scenery flats. Figures are elongated, generalized, and merge with the tectonic details in shallow relief as they might in ancient Greek stylizations. By 1938, Rothko had decisively abandoned expressionist ambiguities in favor of the clear, lighter-toned vision of descending levels called "Subway Scene." This painting is often singled out justifiably as a turning point for Rothko. He himself valued it, and in later years, when visitors asked to see his early work, it was one of the few canvases he ever brought out of the racks. He kept it by him for many years.

From subterranean allusion to freedom of fantasy was then a short step, which Rothko took around 1938. In order to make such a shift, he had to prepare himself intellectually. It was probably then that of all the approaches to myth being discussed (Freudian, Jungian, Marxist, Frazerian etc.) he returned to Nietzsche, hero of the anarchist vanguard in the 1920s.

4

By the 1930s Nietzsche's reputation had suffered many indignities, not the least being his appropriation and misrepresentation by Nazi academics. Only the most intrepid libertarians in America could bear to face squarely the implications of Nietzsche's writings known at the time only in awkward English translations dating back to 1911. Among artists, however, Nietzsche's reputation was secure, partly because the entire early modern movement had been excited by his emphatic address to the darker region of emotions hidden away in the psyche. Numerous late 19th-century philosophers had begun to depend on the observations of the newly established science, psychology, but it was Nietzsche with his extravagant and artistically heightened exposition of psychological phenomena who alerted the burgeoning modernists. His courage in examining the irrational realm did not fail to incite the poets, painters, and composers who, in the late 19th century, felt themselves ready to repudiate the rational tradition in the arts.

In the United States, Nietzsche's presence among artists had a substantial history, going back to Stieglitz's pioneering magazine *Camera Work*, and the Bohemians of the 1920s. For Rothko, it had possibly begun with his interest in anarchism. The old anarchists, especially Emma Goldman, had stressed at least one aspect of Nietzsche's writings: his insistence on the freedom from supersti-

tion. Since, as Nietzsche had dramatically proclaimed, God was dead. . . . The Surrealists had also shown obeisance to Nietzsche. There were increasingly frequent references to him in both French and American Surrealist publications from the mid 1930s to the early 1940s.

There were references to many other dissident voices of the proto-modern period as well, all attacking the positivist tradition of the early 19th century. Amidst this clamor, artists looked to many sources to confirm their own intuitions. Rothko's situation, however, was different. What the renewed interest in myth meant to him found its definition not in the broad scanning that the European Surrealists specialized in, but in an immersion in just one of Nietzsche's books—his very first, *The Birth of Tragedy*. It may well be that it was not so much Nietzsche's defiant re-casting of the definitions of ancient tragedy that attracted Rothko as the less emphasized emotional basis given by Nietzsche in the original edition's title: *The Birth of Tragedy Out of the Spirit of Music*. The young Nietzsche, like the young Rothko, had found immense emotional stimulation in listening to music. In Nietzsche's first book, he artfully sought to account for his own ecstatic emotions in an orderly, philosophic way, but the surging emotion derived from music rose up constantly, often in a poetic diction that presaged Nietzsche's later magnificent style. Rothko, who throughout his life not only listened to music but depended on it for solace, inspiration, release, was peculiarly attuned to the Nietzschean vision of the importance of music. While other painters were often interested in music, worked with music in the background, or even used musical analogies when they discussed their work, for Rothko it was so intimate a need that friends, who rarely agree on Rothko's basic characteristics, always concede that his response to music was fundamental. Not only was it always a presence in his life, but even when he visited others, he spent hours listening rapt, not even turning the leaves of a book. Herbert Ferber describes him lying on the grass in Vermont listening with total attention to the whole of *Don Giovanni*, while Carlo Battaglia remembers Rothko stretched out on a leather couch in Rome, windows open wide above the Renaissance plaza, wakefully attending the same Mozart opera. For Rothko, whose sensibility was so much excited

by music, Nietzsche's text helped to focus disparate intuitions. From music to myth—as Nietzsche's flow of thoughts went in *The Birth of Tragedy*—is the natural trajectory of Rothko's own thoughts.

Nietzsche's conception of the aesthetic meaning of music was shaped by his study of Schopenhauer. Although he argued with the older philosopher on many basic propositions, he remained faithful to Schopenhauer's insights when it came to music, and quoted him at length. Some of these phrases would find echoes in Rothko's later attempts to clarify his vision in words. Certainly the general description of the nature of music in Schopenhauer can be likened to the radical decision in what Rothko later called his "enterprise." Nietzsche's choice of a passage from Schopenhauer's *The World as Will and Representation* indicated his need to be as specific as possible about the effects of music on himself. He quotes Schopenhauer as saying that music, if regarded as an expression of the world, is in the highest degree a universal language. Its universality, however,

> is by no means that empty universality of abstraction, but of quite a different kind, and is united with thorough and distinct definiteness. In this respect it resembles geometrical figures and numbers, which are the universal forms of all possible objects of experience and applicable to them all *a priori*, and yet are not abstract but perceptible and thoroughly determinate. All possible efforts, excitements, and manifestations of will, all that goes on in the heart of man and that reason includes in the wide, negative concept of feeling, may be expressed by the infinite number of possible melodies, but always in the universal, in the mere form, without the material, always according to the thing-in-itself, not the phenomenon, the inmost soul, as it were, of the phenomenon without the body. This deep relation which music has to the true nature of all things also explains the fact that suitable music played to any scene, action, event, or surrounding seems to disclose to us its most secret meaning. . . . When the composer has been able to express in the universal language of music the stirrings of will which constitute the heart of an event, then the melody of the song, the music of an opera is expressive. But the analogy discovered by the composer between the two must have proceeded from the direct knowledge of the nature of the world unknown to his reason, and must not be an imitation produced with conscious intention by means of

concepts, otherwise the music does not express the inner nature, the will itself, but merely gives an inadequate imitation of its phenomenon. . . .[18]

The "direct knowledge of the nature of the world unknown to his reason" was for Niëtzsche, and later for Rothko, a most ardently desired knowledge, and Nietzsche went to great lengths to probe its meaning. In examining the existence of such direct feelings, Nietzsche posited his celebrated definition of ancient tragedy as a fusion of the Dionysian—the spirit of music, with its direct knowledge of creation's sources—with the Apollonian, the daylight revealing "the beautiful illusion of dream worlds in the creation of which every man is truly an artist." Nietzsche knew what Freud and Jung would later assert: that we dream in images.

> Thus the aesthetically sensitive man stands in the same relation to the reality of dreams as the philosopher does to the reality of existence; he is a close and willing observer, for these images afford him an interpretation of life, and by reflecting on these processes he trains himself for life.

The Dionysian, Nietzsche insisted (probably because he *felt*, rather than *thought*, in the presence of music), restored man to nature and "he feels himself a god . . . He is no longer an artist, he has become a work of art." He urges his readers to transform Beethoven's "Hymn to Joy" into a painting in order to understand what he means when he speaks of the Dionysian "feeling of oneness." Art, Nietzsche in his youthful enthusiasm thought, was a "complement and consummation of existence, seducing one to a continuation of life." But, like another very young *exalté* writing in the same period, Rimbaud, Nietzsche felt that there was a primal universe speaking through the artist. Rimbaud said, *"on me pense,"* and Nietzsche said,

> Insofar as the subject is the artist, however, he has already been released from his individual will, and has become, as it were, the medium through which the one truly existent subject celebrates his release in appearance . . . Only insofar as the genius in the act of artistic creation coalesces with this primordial artist of the world, does he know anything of the eternal essence of art; for in this state he is, in a marvelous manner, like the weird image

of the fairy tale which can turn its eyes at will and behold itself; he is at once subject and object, at once poet, actor, and spectator.

When Nietzsche came to criticize his own early work, he referred to the *Birth of Tragedy* as "rhapsodic" and recognized that it was "'music' for those dedicated to music, those who were closely related to begin with on the basis of common and rare aesthetic experiences"—a book for close relatives, as he put it. Rothko, by the nature of his inmost sensibilities, was a close relative. Never very firm in his images when they were wed to the immediate and concrete presence, he could become emphatic once he released himself to what Nietzsche, in his "Attempt at Self-Criticism" prefacing the 1886 edition, called a *strange* voice, a "spirit with strange, still nameless needs, a memory bursting with questions, experiences, concealed things after which the name of Dionysus was added as one more question mark."

> What spoke here—as was admitted, not without suspicion—was something like a mystical, almost maenadic soul that stammered with difficulty, a feat of the will, as in a strange tongue, almost undecided whether it should communicate or conceal itself . . .

It was in this strange tongue that Nietzsche uttered his conception of myth—an image that Rothko found totally congenial, and to which he adapted his own. Moved by the Aeschylean voice—the voice that Nietzsche said created a stage as "the mirror in which only grand and bold traits were represented"—Rothko accepted Nietzsche's version of the mythic in preference to others. He did not have to go to the writings of André Breton to find the fabulous, the miraculous, inhering in the mythic. Nietzsche had already suggested, in a not-so-covert attack on the modern theoretical man, that one could determine to what extent one was capable of understanding myth by asking himself if the miracles represented on the stage insult his historical sense, which insists on strict psychological causality, and whether he regards the miracle as a phenomenon intelligible to childhood, but alien to him.

> For in this way he will be able to determine to what extent he is capable of understanding *myth* as a concentrated image of the

world that, as a condensation of phenomena, cannot dispense with miracles.

Perhaps Rothko sorrowfully saw himself as the modern despaired of by Nietzsche, the "mythless man" who stands "eternally hungry, surrounded by all past ages and digs and grubs for roots, even if he has to dig for them among the remotest antiquities"—an image that could be, perhaps, corrected by art. Like Nietzsche, he turned to the earliest modes of Greek drama. It was Aeschylus to whom he returned; Aeschylus, in whom Nietzsche said the Apollinian and Dionysian were fused, and whose portrait of Prometheus might be expressed in the formula: "All that exists is just and unjust and equally justified in both." If we could imagine dissonance become man, says Nietzsche, "and what else is man?," this dissonance, "to be able to live, would need a splendid illusion that would cover dissonance with a veil of beauty." The early Greek dramatists understood this perfectly. Rothko felt it to be true. He had already indicated in the choice of his subjects his propensity for melancholy and his awareness of dissonance. Now he would move beyond the paralyzing consciousness of unjustness in the world. When Nietzsche tries to elucidate the pessimist's flaw, he reverts to Shakespeare, as did many other late 19th-century thinkers who became fascinated with Hamlet's ambivalence. Rothko followed Nietzsche. He maintained his interest in Shakespeare all his life. Nietzsche, in the famous passage that seemed to so many 20th-century readers an astonishing prophecy of Existentialism, says that the rapture of the Dionysian state leads to a chasm of oblivion that separates the world of everyday reality and Dionysian reality. As soon as "everyday reality" re-enters consciousness, it is experienced with nausea. In this sense, he says, Dionysian man resembles Hamlet for "both have once looked truly into the essence of things, they have *gained knowledge*, and nausea inhibits action; for their action could not change anything in the eternal nature of things; they feel it to be ridiculous or humiliating that they should be asked to set right a world that is out of joint."

In the face of such harsh truths, "man now sees everywhere only the horror or absurdity of existence . . . he is nauseated." Only art, Nietzsche proclaims, knows how to turn these nauseous thoughts about the "horror or absurdity of existence into notions with which

56

one can live: these are the *sublime* as the artistic taming of the horrible, and the *comic* as the artistic discharge of the nausea of absurdity."

As Rothko himself was moving more and more toward a distancing from the "everyday" world, in which he had never felt thoroughly comfortable, much as he had longed to (his appreciation of Avery was explicit on that), he entered a psychological state that welcomed Nietzsche's bitter indictment of the "theoretical man" who seemed to dominate the modern world. In an almost unconscious movement, Rothko had, in his work of the mid-to-late 1930s, rejected even the modern tradition in visual art, a tradition in which he claimed to see a materialist bias, and a disregard for deeper sources. Later he would, through his works, explicitly endorse Nietzsche's insight, particularly in a curious passage where the young Nietzsche contrasts what he calls theoretical man with the artist. Like the artist, Nietzsche observes, the theoretical man finds an infinite delight in whatever exists. The artist, however, whenever the truth is uncovered, "will always cling with rapt gaze to what still remains covering even after such uncovering." The theoretical man, on the other hand, finds the highest object of his pleasure in an "ever happy uncovering that succeeds through his own efforts." Nietzsche's disdain for the happy, conscious drive of the analytic man, so unaware of the mysterious increment even in "everyday life," found answering emotions in Rothko. Rothko's later work could be seen as "what still remains covering." Nietzsche remained faithful to his youthful insight: in the late work, "Nietzsche Contra Wagner," he takes issue with those who "want by all means to unveil, uncover." He has learned "to stop courageously at the surface, the fold, the skin, to adore appearance, to believe in forms, tones, words, in the whole Olympus of appearance. Those greeks were superficial—*out of profundity* . . . Are we not, precisely in this respect, Greeks? Adorers of forms, of tones, of words? And therefore—*artists?*"[19] Nietzsche moved on from *The Birth of Tragedy* toward a more calm clarity, never forgetting, however, the residue of his glance into the abysm. So Rothko would also move. As he said "The progression of a painter's work, as it travels in time from point to point, will be toward clarity. . . ."[20]

The clarity Rothko desired was slow in coming. In the middle-to-

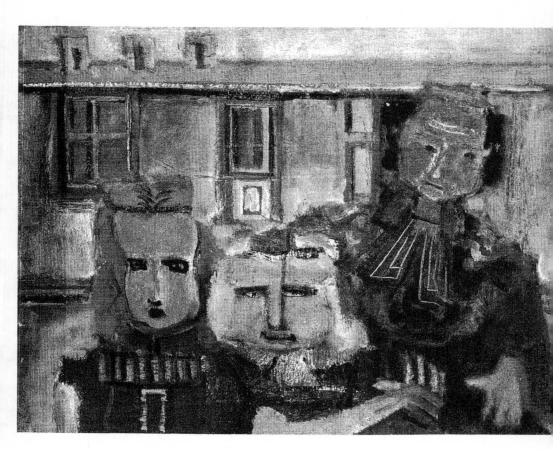

12. Untitled c.1936

late 1930s he experimented restlessly with various voices, various approaches to his pictorial problems. His identification of music as a possible fundament for his expression was not easily translated on the canvas. There are hints about the importance of music in several sketches and gouaches of musicians, or people listening to music. Overtones of his meditation on tragedy also occur in the increasing flatness of his compositions. By reducing the depth of plazas, city-streets, interiors, Rothko simulates the narrow stage and enhances the illusion of backdrops, coulisses, and non-naturalistic props. Tragedy as a richly suggestive subject in itself, probably inspired by his reading of the ancient Greek dramas, begins to emerge sometime around 1936, in sketches and paintings of masked figures. One shows three frontal figures against a flat backdrop of a house façade. The upper figure suggests some reminiscence of Rouault's judges, but the two lower heads are the generalized masks associated with non-naturalistic drama. The central mask plays vaguely on the Janus theme (the left eye is drawn almost as a profile eye) that recurs in the "Antigone" possibly painted as early as 1938, and in a number of works of the 1940s. Was he thinking still of Nietzsche, who skillfully condensed his theory of the Apollinian-Dionysian doublet to the image of the Greek poet Archilochus juxtaposed with the head of Homer, side by side, on gems and sculptures? Homer, as Nietzsche wrote, "the aged, self-absorbed dreamer, the type of Apollinian naïve artist, now beholds with astonishment the passionate head of the warlike votary of the muses, Archilochus, who was hunted savagely through life." He adds that the modern interpretation would be that the first objective artist confronts the first subjective artist. The mask, the "covering," was to prove a central motif in Rothko's break with the figurative expressionist tradition.

The tempo of Rothko's explorations accelerated during the late 1930s. The autodidact was still at work, building his repertory of visual experiences, reflecting upon the nature of art, trying to reconcile his often contradictory impulses. He looked everywhere—not only to ancient sources of Near Eastern art, and Greco-Roman art in the halls of the Metropolitan Museum, but also at the works of the modern period beginning with the early 19th century. Joseph Solman specifically remembers his interest in Corot—a likely source

13. *Antigone* 1938-41

for Rothko to store in his memory. Corot, of whom Baudelaire said: *"toutes ses oeuvres ont le don particulier de l'unité, qui est un besoin de la mémoire,"* and who the modern art historian Germain Bazin echoes in: *"L'œuvre de Corot est donc une sorte de biographie de cette lumière."* It is possible that Rothko's increasingly lightened palette, and its frequent terra-cottas, yellows, and ochers during the last years of the 1930s was informed not only by Avery's corresponding lightening, but by his own appreciation of Corot's "biography" of the Roman light in 1827. There were also opportunities to see exhibitions of the work of Matisse, whose "The Red Studio" had been shown first in 1913 in the Armory show and had been widely reproduced before its acquisition by the Museum of Modern Art in the late 1940s. Matisse's condensations of time and space, which were to be of considerable moment to Rothko in later years, already attracted him—perhaps via Avery—while he was casting about for a likely idiom during the later 1930s. At the Metropolitan Museum he saw the Pompeian frescoes that would also come to possess his imagination in later years. They peer through some of the last figurative paintings. Then, there was Rembrandt, touching other chords in Rothko; Rembrandt with his eloquent manipulation of light, so much like staged drama; Rembrandt who may have inspired one of Rothko's earliest approaches to the drama of the Crucifixion (although Waldemar George had seen another source as more likely—the Italian Trecento).

As the 1930s approached the cataclysm that artists had been dreading for years, it was Miró who, for Rothko, epitomized the Nietzschean, rhapsodic vision of art. Miró was widely exhibited during those years; in the Museum of Modern Art's *Dada and Surrealism* show in 1936, and also at the Pierre Matisse Gallery during the same and following years. In 1941 there was a large retrospective at the Museum of Modern Art. Miró had accepted the revelations of Surrealism. Yet, his poetic temperament stood between him and the philosophic wing of the movement, and protected him from the verbosity and literary extravagances evident in so much of the Surrealist rhetoric. His attitude corresponded to Rothko's dawning realization that he could depart from the everyday world without sacrificing its vitality. There were many statements of Surrealist

61

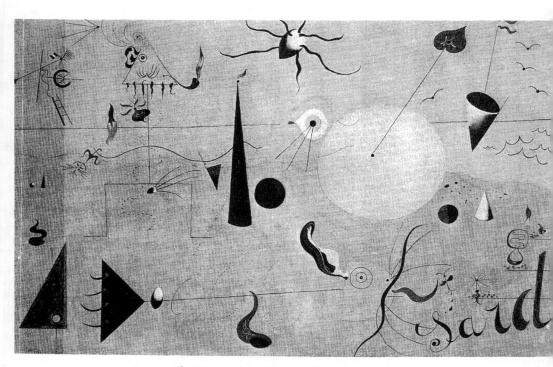

14. JOAN MIRO *The Hunter (Catalan Landscape)* 1923-24

theory published at the time, often in words of artists such as André Masson and Max Ernst, that could have lingered in Rothko's mind as he set to work to demolish his own past. But the statement of Miró, made in the work, was far more effective in spurring Rothko's turning. Miró's evocation of the mythic was itself informed by the excavations of Max Ernst, but Miró had been released from his earlier naturalistic illusionism when he discovered in himself the compelling emotional need for the poetic word. Over and over again he drew near to the poets, not only Eluard and Breton and Desnos, whom he met early in his sojourn in Paris, but also to Novalis, Rimbaud, Baudelaire, and, the poet among philosophers, Nietzsche. Miró specifically designated poetry as his inspiration and goal in the paintings he commenced in 1923. But he was a painter; a painter gathering his inner forces to make the leap that so often appears in his imagery—a leap into time, and into vastnesses such as sky and sea; into the hypnogogic realm posited by Poe and taken up by Baudelaire, in which images flow without causal interference, and time swells and shrinks with a mysterious pulse unknown to the wakeful mind. Breton's stress on automatism—thought's dictation without the interference of fixed mental structures—loosened up his writing colleagues, leaving them more accessible to their fantasies. But for painters, automatism was rarely adequate. Miró certainly dallied with automatism, which for visual artists amounted to exercise or doodling with pen or pencil in which the scribble technique was always linear. But he did not dally for long. (Rothko himself reported briefly experimenting with automatism in the late 1930s, recapitulating Miró's experience and, like the older master, moving on with his linear treasures to more complex experiences with paint.) Gathering up his references to specific images that had once peopled his paintings overtly, and mixing them with the symbolic fusions of imagery derived from the poetic diction of his favorites, Miró launched himself into a universe governed by his own imagination. The painting in which he most clearly eunuicated his new intention was "The Hunter," subtitled "Catalan Landscape," which entered the Museum of Modern Art's collection in 1936. If the translation of time into intercollated regions and simultaneities had attracted Rothko to the work of Eliot, it was projected into spatial

dimensions for him by Miró (who in turn was probably tutored, visually—at least a little—by what he saw in the studio of his neighbor, André Masson). The impact of this painting is apparent in Rothko's oeuvre for years after his first encounter with it at the museum. Miró had made a radical shift in which he found the material means to express his new vision. The means included the simple expedient of thinning his paint to almost transparent tones, suggesting the fluidity of his earth-sea-sky metaphor. The pale pink of the earth is so close in value to the yellows of sea and sky that the incursion of one on the other is easily assimilated by the eye. Scattered at various planes within the basic scheme are the symbolic objects, moored by no law, not even that of gravity. Rothko saw this painting long before meticulous art historical exegeses of the shapes and images were published. What he saw were ambiguous forms and less ambiguous forms treated gaily, and without emphasis, flying in every direction up and down the picture plane. The organization in three regions was cunningly subverted by the seeming disparateness of shapes. Mixed with allusions to organic creatures—forms such as eyes, spiders, human heads, and rabbits—were allusions to geometric figures: the geometer's triangle, a crested cone, spheres, and trylons. Explicitly there is a ladder, an image that so many modern artists had converted from its Christian connotations to the older and more suggestive tradition of Jacob. The painting, bathed in the irreal light—a light of late dawn or early dusk, the fabled golden hours—proposes a union of thoughts and images, a cosmos, that had an inherent magnetism for Rothko. Around the edges of his consciousness the cloud of the irreal was already touched by the golden light that unifies.

5

In those western European countries where democracy had been repudiated, wrote Stuart Davis, national chairman of the American Artists' Congress, in 1937, books were burned, paintings ridiculed and destroyed, music by great composers forbidden to be played, and the "right to studentship in the arts denied except within the barbed wire limits of a mystical and militaristic political censorship." Davis expressed the alarm and consternation of most artists who, having seen the ravages of the Depression in their own milieu, cast apprehensive glances at Europe and repeatedly asked themselves if something were not out of joint even in their aesthetic relationship to their time. Rothko, Gottlieb, Solman, and even mild-mannered Milton Avery were among the many who worried intensively during the late 1930s. They grappled with problems of art and society with an urgency induced by an all too vivid imagining of what it was like to be an artist in Italy, Germany, or Spain. Davis's strong position—that there was a new concept of the meaning of art and its role in society; that "art is one of the forms of social development and consciousness, which is in constant interaction with the other social forms in its environment"—was difficult to counter. Davis anticipated the riposte of his antagonists in a paragraph underlining the central problem:

> In contradiction to this conception of art as a particular but integral part of the social structure, there are some artists and

critics who prefer to think of art as an isolated activity having its own history which is determined by the talent of an aristocracy of genius throughout the centuries. Such a viewpoint limits the meaning of art to a matter of fine taste in certain relations of form and color and ignores the fact that these relations always refer to a concept of natural relations. These idealists observe that works of art have the most diverse subject matter: people, landscapes, still lifes, abstract spatial relations—and they conclude from this that subject matter has nothing to do with art. This is exactly the same as arguing that since we observe life in people, in trees, and in apples, that people, trees, and apples have nothing to do with life, and thus they look for life in the "form" of a disembodied essence, a "non-objective" life without material limitation.[21]

Davis, who always aligned himself with abstract artists, nonetheless drew back from the extreme limits of abstract expression (probably identified in his mind with the de Stijl group) and took the modified Marxist position that art could never transcend its historical circumstances. The notion of an "immanent" art history was derided even by so extraordinary a mind as that of Meyer Schapiro who, reading Alfred Barr's modest introduction to the 1936 exhibition, *Cubism and Abstract Art*, took him to task for "the pretension that art was above history through the creative energy of personality of the artist."[22] An expressionist artist who, like Rothko, had worked for years on the assumption that "spirit, expressiveness and personality" were the real meaning of art, was in an extraordinary quandary during the late 1930s, when increasingly his personal responses to nudes, trees, and apples seemed not only irrelevant but perhaps immoral. It was at this juncture that Nietzsche's exploration of the collective basis for universal expression provided an alternative. The nonhistorical bias of myth flew in the face of Marxist theory, but it also assuaged the social conscience of the perturbed artists who felt the weight of their time and wished to respond responsibly to the calamity.

Rothko continued to be exceptionally active in the civic affairs of artists and was clearly preoccupied with the moral conflict Stuart Davis had underscored. With his comrades he had picketed when the government seemed to be reneging on its commitments to the WPA; he had attended mass meetings and had experienced the

solidarity his youthful ideals had envisioned. But he was no longer a raw youth. He was a man in his middle thirties, well aware of inherent conflicts even in the principle of union. For a time, a political radical who was also an artistic radical could make common cause with those taking tendentious positions. But there came a moment when the political and ideological struggles became too bitter. On April 4, 1940, the American Artists' Congress held a disastrous meeting during which it passed a resolution that to many passionately dissenting members appeared to sanction the Russian invasion of Finland. Immediately Meyer Schapiro, Ilya Bolotowsky, Lewis Mumford, Adolph Gottlieb, Stuart Davis, and Balcomb Greene resigned. Within days a statement appeared, signed by Avery, Bolotowsky, Gottlieb, Harris, and Rothko, among others, explaining the move and calling for a new organization. They accused the American Artists' Congress of implicitly defending Hitler's position by assigning the responsibility for the war to England and France, and failing to react to the Moscow meeting of Soviet and Nazi art officials and official artists "which inaugurated the new esthetic policy of cementing totalitarian relations through exchange exhibitions." The Congress, they said, no longer deserved the support of free artists. Two months later the Federation of Modern Painters and Sculptors was founded after many animated meetings to hammer out its goals. The formative meetings resulted in a concept of organization which would, or should, successfully avoid any artistic restrictions, but which could still maintain the old ethical positions of the 1930s that demanded of artists that they attend to social and political questions conscientiously. In the preamble to its constitution, the founders stated

> We recognize the dangers of growing reactionary movements in the United States and condemn every effort to curtail the freedom and the cultural and economic opportunities of artists in the name of race or nation, or in the interest of special groups in the community. We condemn artistic nationalism which negates the world traditions of art at the base of modern art movements.

From the beginning Rothko was committed to the Federation's program. His close friend Gottlieb was on the executive board, and Rothko was active on the cultural committee. He took responsibility

for bringing in discussants, inspiring public forums, and looking for issues to which the organization should address itself. He took the educational role of the Federation seriously, urging widespread activities and publications, and exhibited for many years in their exhibitions. The diversity of the group was noted by the critics, who were generally pleased. Henry McBride wrote on May 22, 1942, in the New York *Sun* that "the requirements for joining the society apparently, are merely just not to be academic."

These outside activities seemed only to spur Rothko in his energetic drive to clarify the meaning of his own work; to "see the world as if for the first time." By 1938 he had begun to explore the pictorial possibilities of the Nietzschean vision. Hearing the two voices—the urgent voice of history and the distanced voice of myth—Rothko immersed himself in a struggle to talk about a subject with meaning, and at the same time, to talk as a painter talks. "Antigone" painted sometime before 1942 probably (possibly in 1938, as Rothko thought), is one of several paintings derived from the Greek bas-relief and other ancient sources. The masks in the top register are either chorus or gods, their terra-cotta color recalling Greek vases; the buttocks of the performers are in a middle ground, and the feet—both animalesque and human, true to the protean character of myth—rest on a stage-like pediment below. No question here but that the Greek tragedy was the source of his new stance. All this was accomplished in hesitant pale tonalities, often ochers and tans, with occasional Aegean blues or with terra-cotta grounds that insist on the Greek source. In these friezes of the late 1930s and early 1940s, Rothko initiates archaeological meditations in the form of horizontal divisions that formalist critics see as the source of his later spare abstractions with their two, three, or four levels or divisions. At the time they probably provided Rothko with the means to pictorialize his intuitions of layered time; of the metamorphic character of myth, and of the clear structure of Aeschylean drama (both on the formal and the psychological level; the chorus and the heroes and the gods and the people being clearly defined in a stylized dramatic format).

If Rothko was moving into another range of sensibility in the confines of his studio, he was not yet ready to expose himself to the scrutiny of the public. As a member of The Ten, he had exhibited

extensively but had rarely won approval. Solman quotes Lou Harris who reported that Rothko smarted from the fact that his name was so rarely mentioned in the reviews, saying, "If only they would say Rothko stinks!" In 1940 he had an opportunity he accepted with alacrity. J. B. Neumann, whose opinion Rothko valued, offered to exhibit his work together with that of Solman and the French Expressionist Marcel Gromaire. It was at this time that Rothko decided to shorten his name from Marcus Rothkowitz to Mark Rothko. Rothko was still treading cautiously between his Expressionist preoccupation with moody figurative works and his new impulse to abstraction. Gromaire was much admired in Europe for his proletarian sympathies, described in grim brown-to-black visions of workers and peasants, powerful in their structure and superior to anything in the genre in the United States. In the exhibition in January 1940 Rothko apparently showed only the elegiac subway scenes and a few figure studies. His reticence continued that spring and the following in Federation shows, where he again exhibited the subway paintings. It wasn't until Sam Kootz, a progressive young dealer, organized a large exhibition at Macy's in January 1942 that Rothko publicly exhibited his Greek paintings "Antigone" and "Oedipus." That same year Peggy Guggenheim opened her Art of This Century Gallery.

During the Neumann show, Max Weber visited, and to Rothko's visible satisfaction warmly praised his work. Although Weber himself had long since moved from his early preoccupations, he remained faithful to the broad aesthetic precepts of his youth. Weber was still a firm believer in the mysterious power of the art of primitives. If Rothko began to pay close attention to Oceanic, African, Mesopotamian, and Archaic Greek visual arts, it was partly thanks to his early attention to Weber's teachings. As early as 1910 Weber was writing in Stieglitz's *Camera Work* about the superior expressiveness in the colors used by the Hopi in their katchina dolls, baskets, and quilts. Fifteen years later André Breton would call attention to native American art of the Southwest in his magazine *The Surrealist Revolution,* and fifteen years after that the Americans began to take cognizance of their own indigenous "primitive" arts as well as the primitive in other cultures.

In September 1940 Charles Henri Ford founded *View,* which was

to be a lively extension of French Surrealist publications. The honored stars—Miró, Masson, Ernst—were discussed, illustrated, probed, and their "primitive" antecedents exposed. In 1942 there was an entire issue on Max Ernst. Surrealist interests were explored anew on American soil, sometimes by the old French band themselves who, escaping the war in Europe, foregathered noisily in New York. They brought with them their proudly brandished self-consciousness. The irony they injected—that the consciousness of self required an unconsciousness—was not lost on the New York artists who were still wrestling with their responsibilities in the wakeful world. The burden of consciousness was acknowledged by most of the New York painters who sought eagerly to unburden themselves. But they could not entirely banish their puritanical legacy. For most artists who would become New York School abstract painters, the Surrealist lunge into the unconscious was somehow shameless. What of the grand themes? Rothko, who may have remembered Clytemnestra's "Ah, it is sweet to escape all necessity'," was still troubled by the problem of meaning. He held a Bergsonian vision of the biological origin of consciousness, and understood the subterranean movements of the psyche to be somehow functions of a creative evolution. In one part of his soul, he was determined to express this psychological, yet historical, insight. In another, his encounter with the febrile modes of the painting Surrealists was for him a great release, a sweet escape. Surrealism was the elixir that could slake his thirst for revelation.

During the early 1940s, Rothko, Gottlieb, and their frequent companion, Barnett Newman responded actively to the presence of the Europeans. For several years they had despaired of their situation in a country that increasingly endorsed a nationalistic art pretending to epitomize a new aesthetic. Their disdain for American Scene painting, and realism in general, was total. Newman, sometime around 1942, still was fulminating against "isolationist art," pointing to a cunning strategy of the isolationist masterminds who, knowing the clock could not be turned back, agreed that modern aesthetic did not permit a re-emphasis of a subject matter. "And if subject matter isn't important, so what is? It's *how* the subject is painted. If it is a good picture it makes no difference what is

painted."[23] Here he broached one of Rothko's most persistent themes: that manual skill was irrelevant; that "pictures" were not enough, and that the meaning of life was the real subject matter of an artist. There is some justice in seeing both Newman's and Rothko's defiance of French painterly cuisine in terms of their own shortcomings. Neither had ever had the rigorous training that could endow their fingertips with the unthinking skill to manipulate the elements of pictorial art. Newman had been particularly malhabile. Rothko had laboriously sought the means through countless experimental canvases. For him the indications in Surrealist art that a painter could use any means dictated by his subject matter were to be catalytic. The innate American suspicion of European cultivation seemed neutralized by the Surrealists' blithe renunciation of their own finesse, and their daring anarchy. Even so, the Whitmanian value of directness and innocent crudity always accompanied the American artists' bows in the direction of European culture. The attitude that wished to preserve American traits of independence had been a clear motivating force for American artists throughout their history. Whitman epitomized it when, in 1857, he wrote of Keats's poetry:

> Its feeling is the feeling of a gentlemanly person lately at college accepting what was commanded him there—who moves and would only move in elegant society reading classical books in libraries. Of life in the 19th century it has none, any more than statues have. It does not come home at all to the direct wants of the bodies and souls of the century.[24]

Rothko whose romantic anarchism had led him to bum in the loft manufactures of New York, and whose commitment to social justice had deep roots, was intellectually inclined to render justice to "the direct wants of the bodies and souls of the century." Temperamentally, he was better suited to the romantic vision of what Baudelaire called "the heroism of modern life." What he saw when Peggy Guggenheim opened her gallery was a succinct compendium of every modern idiom extant—not only Surrealist. Too thoughtful to evade the implications, Rothko charged himself with an arduous appraisal of the various stylistic responses to the modern world. If he was to navigate in a world that was patently out of joint, a world

71

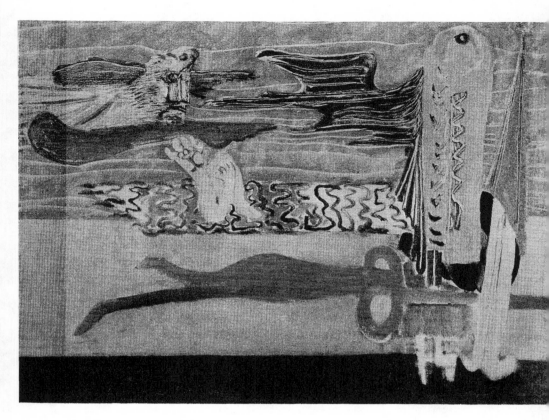

15. *Horizontal Phantom* 1943

shattered by war and mired in the absurd, he wanted to be able to read his own compass. The "despair" of which so many painters spoke in 1940 (Newman: "In 1940, some of us woke up to find ourselves without hope"; Gottlieb: "During the 1940's, a few painters were painting with a feeling of absolute desperation"[25]) was not, as too many have assumed, only an aesthetic despair, but a despair born of events, *among which* one could include aesthetic events. Rothko sought to situate himself to be able to express the great clash of forces that could stand for what he knew. He begins with the Greek tragedies. His "Agamemnon" with its eagle rendered with a reminiscence of the American eagle of the Northwest Indians, combined with lips, claws, eyes drawn perhaps from Mesopotamian friezes, is a direct allusion to the fire of the classical world. Other paintings of the same period are filled with eyes, ears, and flames, as well as the iconographic symbols of medieval magic. Critics have seen both Masson's sinuous symbols of ecstatic man and beast, and Ernst's geologic references in works of the period, but these echoes are among many others. (For instance, America did not have to wait until Barnett Newman staged an exhibition of Pacific Northwest Indian art at the Betty Parsons Gallery in 1946. Kurt Seligmann, who settled in New York at the outbreak of the war, had already published an article in the 1938 edition of *Minotaure* on the totems and fetishes of the Haida.) Around 1942 Rothko painted a synoptic fusion of his imagination's sources. The feathered bird (eagle?) is decidedly American Indian. The eye is not Egyptian or Surrealist-dissected, but the eye of a biblical patriarch, or an Aeschylean elder, whose Expressionist hands are made to wring and whose cloud of beard is emphasized by the Ernst-like striations, made with the wooden handle of Rothko's brush. These Aeschylean overtones are sustained in many watercolors of the period. The fluid watercolor medium released the linear impulse with which the surrealists had limbered up their unconscious. In the oil paintings, which began to show distinct signs of Rothko's mounting assurance, not only in the greatly improved paint technique but in the handling of larger formats, the will to speak of the grand tragic themes is even more pronounced. In 1943 he painted "Horizontal Phantom," a fully orchestrated work with the newly lightened pal-

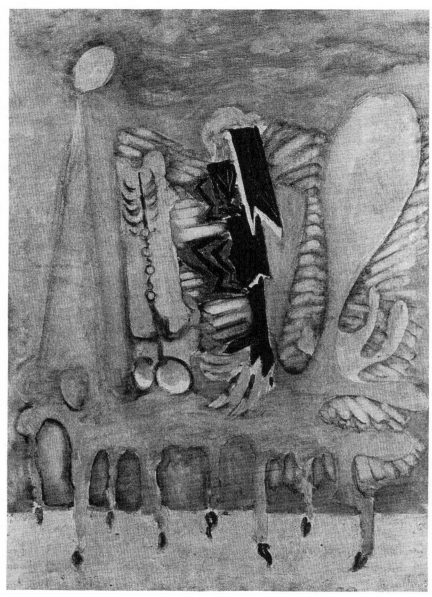

16. *The Syrian Bull* 1943

74

ette derived from Avery and Miró. Here are hints of Miró in the Merlin hat that cloaks a pink-legged figure on the right; hints of Picasso in the amphora-shaped figure prostrated (perhaps Iphigenia again being sacrificed); hints of Goya in the ghostly bird hovering in the sky; hints of American Indian totem poles in the phallic orange shape crested with an eye and bearing blood-color wings; hints of the Greek chorus in the gesture of hands that emerges from a water passage with waves rendered in a system of strokes very much as Avery characterized them. The whole is cast in three registers of time and space with movement suggested in the raking white lines scraped with the brush handle. The technical resourcefulness here can be attributed to Rothko's glances at other artists, among them the Surrealists from Europe and his own colleagues who, like him, were studying Klee, Kandinsky, and Picasso, among other 20th-century moderns. The subject matter—there had to be subject matter of significance for Rothko—was, as it was also in "The Syrian Bull" of the same year, meant to span human history, and to suggest its origins in the ancient Mediterranean basin—not only its origins in the human imagination, but its Darwinian origins, which would suggest the ground, the very matter from which consciousness, or rather imagination, would emerge. The welter of visual sources during the early 1940s, carefully documented recently in several scholarly analyses, were, in Rothko's case at least, adapted to his gathering awareness of a specific philosophic stance.

A public awareness of Rothko's awareness was about to become, for the first time, visible. In 1943 Rothko exhibited "The Syrian Bull" and Gottlieb "The Rape of Persephone" in the Federation's Third Annual exhibition, presented with a statement by the organizers that "we are now being forced to outgrow our narrow political isolationism" in order to recognize "cultural values on a truly global plane." Since most of the Federation's members were interested in developing a respectful public for their art, they actively tried to engage press critics in a public dialogue. Edward Alden Jewell, who was a shrewd journalist and knew the value of controversy, gladly fell in with the educational aspirations of the Federation. In a long review of the 1943 Annual, he wrote of his "befuddlement" over Gottlieb's painting, and his bafflement over Rothko's

"Syrian Bull." A few days later he reviewed his review and announced to readers that the Federation would reply to this befuddlement. And, a few days after that, June 6, 1943, he returned again to the show and the "enigmas" of Rothko and Gottlieb, this time reproducing both paintings. He then on June 13 reproduced sections from a June 7 letter from Rothko and Gottlieb. He must have gratified the cultural committee of the Federation when he suggested that the Federation might be spawning a new movement called "globalism."

There are various accounts of how the famous letter came to be written, but judging from an extensive series of drafts in Rothko's papers at the Rothko Foundation, it would seem that he first had the idea of answering Jewell's provocative remarks on his own behalf. After many drafts he probably checked with Gottlieb who volunteered to collaborate and promptly telephoned Jewell to offer the joint letter for publication—an opportunity Jewell wisely accepted. The original drafts with their minute variations indicate how strongly Rothko felt about defining his mission. He struggled to find the precise locutions, and laid stress upon the background for his position in modern thought. Thoughts echoed in the final letter appear in Rothko's notes, such as:

> Why the most gifted painters of our time should be preoccupied with the forms of the archaic and the myths from which they have stemmed, why negro sculpture and archaic Greeks should have been catalyzers of our present day art, we can leave to historians and psychologists. But the fact remains that our age [is] distinguished by its distortions, and everywhere the gifted men whether they seat the model in their studio or seek the forms, all have distorted the present to conform with the forms of Ninevah, the Nile or the Mesopotamian plain. . . . To say that the modern artist has been fascinated by the formal aspects of archaic art is not tenable. Any serious artist will agree that a form is significant insofar as it is expressive of that noble and austere formality which these archaic things possess. . . .

> I am neither the first nor the last compelled irretrievably to deal with the chimeras that seem the most profound message of our time. . . .

In another draft, Rothko again links the return to ancient motifs to the modern sensibility:

The truth is therefore that the modern artist has a spiritual kinship with the emotions which these archaic forms "imprison" and the myths which they represent. The public therefore which reacted so violently to the primitive brutality of this art reacted accurately, more truly than the critic who spoke about forms and techniques. . . .

And in still another draft, Rothko alludes to the condition of the period, and his shock in the face of the terrible public events:

Perhaps the artist was a prophet and many decades ago discovered the unpredictability which lay under man's seemingly ascending reason, or saw the potentiality for carnage we know too well today . . . the artist paints what he must . . .

There are still artists who still confound sunset and long shadows; the melancholy aspects of the times of day with the tragic concepts with which art must deal; but in all the art which jolts, moves and instigates to new discoveries is the art which distorts . . .

These drafts, with many erasures, recapitulations, penciled hesitations, and exclamations, speak of Rothko's continuing meditation on the grand tragic themes. His reading in the Russians, particularly Dostoyevsky and Tolstoy (whose *The Death of Ivan Ilyich* was one of Rothko's strongest incitements—he mentioned often the impact this stern and uncompromising *memento mori* had had on him), is reflected in the constant allusion to the irrational in man and his tragic position. When Rothko joined forces with Gottlieb, the letter became more assertive, marked less by Rothko's melancholy turn of mind.

Seizing the opportunity to formulate their principles in a public forum, Rothko and Gottlieb, with editorial advice from Barnett Newman, who may have written the first paragraph of the letter, warmed to the task. They allowed themselves boyish extravagance and heavy-handed sarcasm. The anarchist instinct to belabor authority came out strong in Rothko (whose ideas may have dominated here, as certain friends have insisted). He, in turn, was probably cheered on by the redoubtable anarchist Newman. As a point of honor the authors begin with a sarcastic attack on the workings of the critical mind, "one of life's mysteries." They chortle in rather

sophomoric tones that it is "an event when the worm turns and the critic of the times quietly yet publicly confesses his 'befuddlement,' that he is 'non-plussed' before our pictures at the Federation Show." They then declare that they do not intend to defend their pictures, which they consider clear statements—the proof of which is Jewell's "failure to dismiss or disparage them." This the painters regard as "prima facie evidence that they carry some communicative power." They do not intend to defend their paintings, but *not* because they cannot—an "easy matter" to explain, as Rothko points out concerning "The Syrian Bull," which he calls "a new interpretation of an archaic image, involving unprecedented distortions." "Since art is timeless, the significant rendition of a symbol, no matter how archaic, has as full validity today as the archaic symbol had then." He adds, with an arrogance no doubt donned for the occasion, "Or is the one 3,000 years old truer?"

In the fifth paragraph, the painters settle down to serious business. No possible set of notes can explain our paintings, they declare, because

> explanation must come out of a consummated experience between picture and onlooker. The appreciation of art is a true marriage of minds. And in art, as in marriage, lack of consummation is ground for annulment.

This was, and remained, one of Rothko's most cherished principles. (Rothko is definitely the sole author of the fifth paragraph.) Its long life in the history of aesthetics was known to him, and known specifically through his careful reading of Nietzsche who in turn had carefully read Schopenhauer. Theories of the potential communion between artist and receiver had floated down the mainstream of modern thought from the Romantic period onward. Of all the theories of aesthetics, the one that appealed most to Rothko's imagination was one that insisted on the reciprocity of artist and viewer, of artist and the world—a theory of empathy that had been favored since the 19th century. Implicit in 19th-century attitudes shaped by the Romantic spirit was a belief in the dynamic process initiated by nature within the artist and transmitted to others who, in their own imaginations, complete the process.

After their arch preliminaries, Rothko and Gottlieb spell out their program soberly, producing one of the few manifestoes of the Abstract Expressionist era. Rothko's allegiance to Nietzsche is apparent in the first point:

> 1. To us art is an adventure into an unknown world, which can be explored only by those willing to take risks.

His yearning for release from necessity appears in the second and third points:

> 2. This world of the imagination is fancy-free and violently opposed to common sense.
> 3. It is our function as artists to make the spectator see the world our way—not his way.

In the fourth point the artists revert to a belated recognition of long-held assumptions of modern artists:

> 4. We favor the simple expression of the complex thought. We are for the large shape because it has the impact of the unequivocal. We wish to reassert the picture plane. We are for flat forms because they destroy illusion and reveal truth.

In the fifth and most important point, Rothko declares once again, as he had already hinted in the *Whitney Dissenters'* catalogue, and in his notes for the Brooklyn Academy speech, that mere manual skill is not enough; that the high seriousness of the artist goes beyond technique and decoration. Again, Nietzsche's characterization of Dionysian man who feels it ridiculous or humiliating that he be asked to set right a world that is out of joint underlies the statement. Nietzsche's solution—that only the artist can turn the horror or absurdity of existence into notions with which one can live— seems to be the one Rothko is proposing with the statement:

> 5. It is a widely accepted notion among painters that it does not matter what one paints as long as it is well painted. This is the essence of academicism. There is no such thing as good painting about nothing. We assert that the subject is crucial and only that subject matter is valid which is tragic and timeless. That is why we profess spiritual kinship with primitive and archaic art.

This general statement of principle was amplified five months later on October 13, 1943, when Rothko and Gottlieb broadcast on WNYC at the invitation of Hugh Stix, whose activities included running a gallery for experimental artists. It is clear that the text for the broadcast was carefully worked out in advance, and that the two painters set great store by the lucid enunciation of their principles. The tone reflects, certainly, their excitement, both at the attention they had received since the *New York Times* coverage, and their own rapid evolution in their work. The immediate occasion was an exhibition of portraits by Federation members, "As We See Them," in which Rothko showed a painting called "Leda" and Gottlieb showed his "Oedipus." Gottlieb introduces the subject by posing four questions he claimed were asked by a correspondent, asking Rothko to answer the first: Why do you consider these pictures to be portraits? Rothko responds that there is

> a profound reason for the persistence of the word "portrait" because the real essence of great portraiture of all time is the artist's eternal interest in the human figure, character and emotions—in short in the human drama. That Rembrandt expressed it by posing a sitter is irrelevant. We do not know the sitter but we are intensely aware of the drama. The Archaic Greeks, on the other hand used as their models the inner visions which they had of their gods. And in our day, our visions are the fulfillment of our own needs. . . . What is indicated here is that the artist's real model is an ideal which embraces all of human drama rather than the appearance of a particular individual.
>
> Today the artist is no longer constrained by the limitation that all of man's experience is expressed by his outward appearance. Freed from the need of describing a particular person, the possibilities are endless. The whole of man's experience becomes his model, and in that sense it can be said that all of art is a portrait of an idea.

Gottlieb then addresses himself to the next question: Why do you as modern artists use mythological characters? He asserts that artistically literate people have no difficulty grasping the meaning of Chinese, Egyptian, African, Eskimo, Early Christian, Archaic Greek, or even prehistoric art, and that he and Rothko use images that are directly communicable to all who accept art as the language of the